Representing Britain 1500–2000

100 works from Tate collections

Martin Myrone

Representing Britain 1500–2000

100 works from Tate collections

Tate Publishing

Published to celebrate
Representing Britain 1500–2000
Displays from the Collection,
sponsored by BP Amoco

ISBN 1 85437 321 8

A catalogue record for this publication
is available from the British Library

Published in 2000 by order of
the Trustees of the Tate Gallery
by Tate Gallery Publishing Limited,
Millbank, London SW1P 4RG

Designed and typeset by Rose-Innes Associates

Printed and bound in Belgium
by Snoeck-Ducaju & Zoon

cover illustrations

left: British School, seventeenth century,
The Cholmondeley Ladies c. 1600–10

right: Lucian Freud, *Girl with a White Dog* 1950–1

Contents

Foreword

This book is both a celebration and a re-examination of one hundred works from the Tate's unparalleled collection of British art. Its pages sweep some five hundred years, and its engagement with art that touches a wide variety of British subject matter, by artists of many national origins, reflects the scope and the remit of the new gallery at Millbank – Tate Britain, launched in spring 2000.

The original Tate Gallery at Millbank was founded in 1897, through the determination and benefaction of the sugar magnate Sir Henry Tate, as a national gallery of British art. Initially operating as a kind of annexe to the National Gallery in Trafalgar Square, its focus was to be exclusively on recent and contemporary British art: at the core of its collection was Sir Henry's own gift of sixty-five modern paintings, and additions were to be confined to the work of British artists born after 1790. But the natural impetus this gave to exploring the concepts of both the modern and the British led perhaps inevitably to an extension of the benefactor's original aims. By 1917 the decision had been made to embrace international art of the twentieth century and also to expand the collecting of British art into earlier, pre-nineteenth-century periods. Since then the Tate has pursued both objectives vigorously and with notable success, and the openings of Tate Liverpool in 1988 and Tate St Ives in 1993 have encouraged continually improving access to a growing collection. But by the 1990s the pressure on gallery space at Millbank itself had become acute and the logic of displaying international modern art in one London building, and British art from c. 1500 to the present day in another, brought about the birth of Tate Modern at Bankside and the rebirth of Millbank as Tate Britain.

The Tate's first century produced a rich legacy not only in terms of the collection but also of curatorial expertise, published scholarship, and standards of exhibition, display and education. And until at least the

late 1970s, when the study of art history at university level began to become distanced from the more traditional, connoisseurial approach to art favoured by museums and galleries, the Tate's particular leadership in the field of British art studies was unrivalled. During the 1980s and 1990s new approaches to art history – in which art was considered within an increasingly broad cultural framework – spread from universities to schools and through to wider public consciousness, challenging museums and galleries to review their principles of display and interpretation in response to a new climate. The Tate's freshly reaffirmed commitment to applying the best of new scholarship to the process of presenting and commentating accessibly upon art for a broad audience is one direct consequence – an ethos that is also manifested in this book, which begins to consider the significance of Tate works not only within their traditional frame of reference in fine art but also through their interplay with the social worlds from which they came and with ideas under debate in Britain now.

Though the concept of a national gallery of British art may not seem automatically modern, with its roots in a nationalist, centralist Victorian ethic scarcely in harmony with twenty-first century society, Tate Britain's agenda is determinedly contemporary. As its title, and the name of this book, tend to imply, its concern is with art's place in the political and cultural entity that is Britain – and questions about art's contribution to varying kinds of national identity will certainly form an undercurrent to our programme of displays, exhibitions and publications. In today's immediate climate of progressive regional devolution on one hand and European integration on the other, and with increasing awareness of a population re-presenting many ethnic and social positions, interrogating the roles of art in defining and challenging ideas of national identity may be a responsibility for Tate Britain, but it is also an exciting opportunity. For as well as providing a rich diversity of meaning and aesthetic pleasure, art can offer a key to opening up some of the pressing questions and debates about the nation, its history and its future.

Tate Britain's programme is not intended to be an extended investigation into the Britishness of British art. But there is a clear commitment to considering the Tate's collection in new ways. We have begun, for example, to make more use of Millbank's conjunction under one roof of historic, modern and contemporary art – art from six centuries, from the sixteenth to the twenty-first. Rather than presenting and interpreting individual works only in relation to their immediate peers or periods, some of our displays and exhibitions are deliberately exploring how art across the centuries has interacted with a range of circumstances and conditions, with particular kinds of subject matter, and with a variety of reference points far beyond the history of stylistic development that has been the traditional preoccupation of the art museum. This means

that some of the Tate's best-known British works are appearing in Millbank's galleries in fresh contexts – a nostalgic Hitchens landscape from twentieth-century wartime Britain, for example, beside an eighteenth-century Gainsborough that helped inspire it, or Spencer's visions set among the works of his visionary heirs and forebears. These new and sometimes surprising settings for even the most familiar works will, I hope, be one way of actively encouraging the appreciation and understanding of British art by all our visitors.

In so doing a familiar history of art is at one level being superseded by more various, more exploratory, and often more exhilarating journeys, linking the art of past and present more readily together. Through these and other means we are renewing our efforts to confirm our role at the very centre of art-historical debate. Today this must mean addressing, from time to time, kinds and categories of art from beyond the Tate's core collection. So we are also pursuing loans of, for example, early sculpture, decorative arts, prints and photography, to enable a wider, more vibrant story of British art to emerge. In encompassing a greater variety of visual arts, Tate Britain may be able more effectively to foreground areas of cultural activity unevenly represented in the permanent collection. Indeed the presentation of multiple, alternative stories about Britain and its arts, and the emergence of challenging critical voices, has been characteristic of recent art history and criticism more generally, and offers particularly rich potential for innovation and variety in the context of this gallery. Thanks to the like-minded spirit of sister institutions such as the Victoria & Albert Museum, with whom we are collaborating in terms of collections loans as well as curatorial input, and thanks also to the participation of scholars and curators representing a diverse range of methodologies and ideologies, Tate Britain's programme for displays, exhibitions and publications is, I believe, impressively broad in its visual range and intellectual ambition. Far from being hidebound to tradition, this reinvention of the old concept of a gallery of national art may prove an innovation appropriate to the new millennium. Meanwhile, I am extremely grateful to Martin Myrone for providing a succinct account of some of the works, and some of the ideas, that will play on Millbank's stage in the years ahead.

Stephen Deuchar
Director, Tate Britain

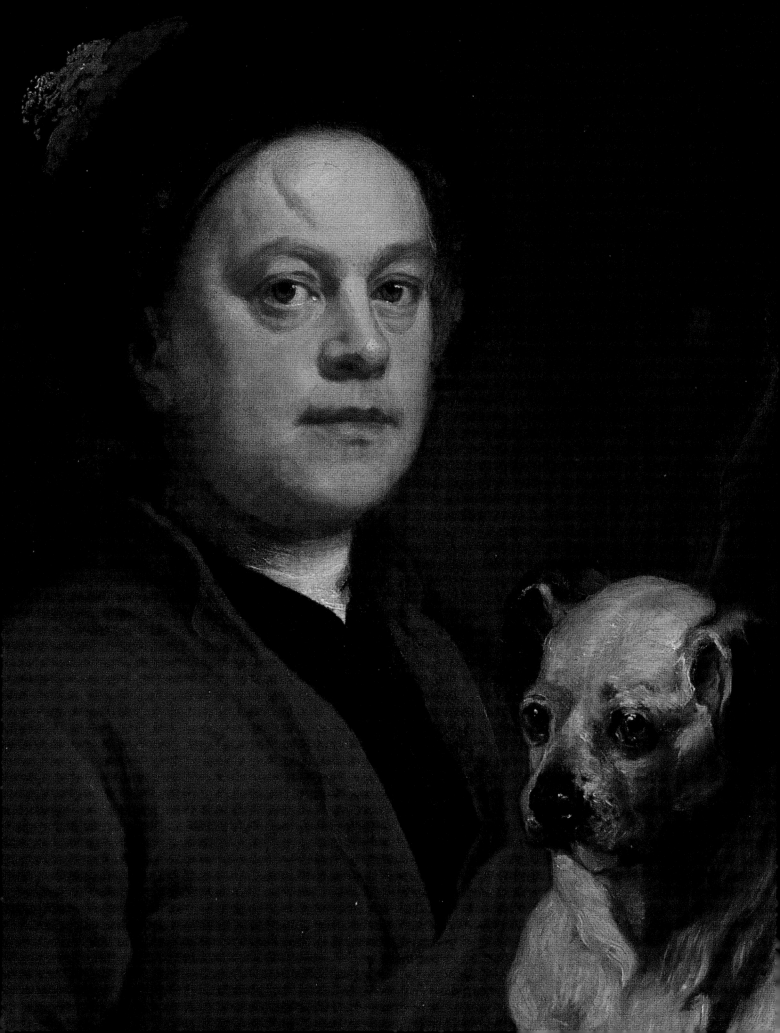

Introduction

The five hundred years of British art represented in Tate collections includes some of the most moving, memorable and inspiring images produced within the Western tradition. Even in a relatively restricted selection of one hundred works, the vitality and sheer quality of British art across the centuries is apparent. The following selection illustrates works by the most famous artists from Hilliard and Van Dyck, to Hogarth, Constable and Rossetti, and in the twentieth century, Spencer, Bacon, Hockney and Freud, and examples from leading contemporary artists including Chris Ofili and Gillian Wearing. Alongside these, works by lesser-known artists, including Jan Siberechts, Philip Mercier, Anna Lea Merritt and Ronald Moody testify to the diversity and richness of the British art scene in all periods.

Together, these one hundred works illustrate the manifold shifts in technique, subject matter, style and ambition that are the most traditional preoccupations of art history. They also embody countless stories of personal and political oppression, hope, ambition and vibrant revolution that reveal much about the changing role and purpose of visual art, and still more about the world these objects were created in, and the cultures that have played host to them since. This selection has been made with the intention both of giving a sense of the history of British art and of indicating some of the bigger stories about Britain and its visual cultures.

There are innumerable ways of looking at the collections, each time charting different kinds of historical stories, tracing different connections and discontinuities across the centuries. This can be achieved by constructing a finely wrought historical argument, or by simply wandering through the galleries. No one story has any natural privilege, although, of course, across time and between cultures certain stories

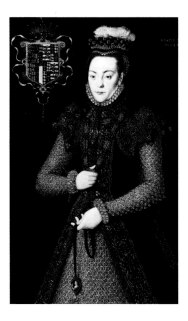

Hans Eworth
active 1540–1573

Portrait of an Unknown Lady
c. 1565–8
Oil on oak panel
99.8 × 61.9 cm

The sitter's sumptuous clothing and jewelry indicate that she must have been of the highest social rank. The Dutch painter Eworth was the leading portraitist of his time. His work combined a highly decorative treatment of costume with a more naturalistic handling of his sitter's features.

are prioritised, revised and invented, and we confer greater authority on the stories told by some individuals than those told by others. In whatever context, any attempt to yoke together diverse works into a homogeneous 'tradition' is almost always suspect. It is by no means coincidental that the most vigorous attempts at creating an overarching myth of the Britishness of British art have generally emerged during periods of political, social and economic stress that challenge inherited notions of national identity. Examples would include the ideas about national landscape in the period of the Napoleonic Wars, the revival of Romanticism in the 1930s and 1940s, and the reclamation of various figurative traditions in the Thatcherite era. Rather than presenting the purported traits of a British tradition, this introduction proposes three different routes through the history of British art as represented by the Tate's permanent collection, by looking briefly at broadly defined themes relevant, in various ways, across history. Each of these, even loosely understood, represents an alternative but complementary approach to British art and suggests a different 'take' on works in the collection.

Private and Public

During the sixteenth and seventeenth centuries only the upper strata of society had ready access to the kinds of visual art that have been preserved into modern times, and only the very wealthiest were able to commission the original works of painting by the most skilled artists that have been deposited with the Tate. By some degree, the bulk of these surviving works are portraits. With the prohibition of images in public places of worship following the Protestant Reformation of the mid-sixteenth century, painters were

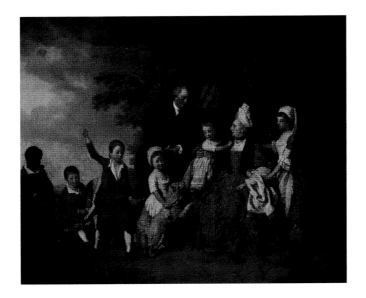

Francis Wheatley
1747–1801

A Family Group in a Landscape
c. 1775
Oil on canvas
101.6 x 127 cm

This painting successfully combines an illusion of informality and naturalness, with a rigorous expression of each sitter's status within the family. The whole group is arranged in a pyramid, with the father of the family at the top, and the black servant at the very bottom.

almost exclusively tied to court circles and were preoccupied with producing images of their patrons and their patrons' families and antecedents. The English court employed a succession of artists, almost exclusively drawn from foreign backgrounds: Hans Holbein, Daniel Mytens, Sir Anthony Van Dyck, Sir Peter Lely. They were joined, at this time only occasionally, by artists British by birth or upbringing, notably John Bettes, Nicholas Hilliard and Marcus Gheeraerts. Within courtly culture, portraits served a variety of roles, as memorials of dead relatives, records of beauty or worth, proof of dynastic blood-ties or elaborate allegories commenting on current or historical affairs. Generally such portraits were not intended to give a strong sense of individuality. Rather, these artists used a repertoire of devices for suggesting social standing and personal worth, which was joined to a highly ritualised culture of courtly display and play.

With the emergence of modern-style business and banking in the late seventeenth century, and the erosion of the last traces of the old feudal culture centred on the monarch, the social character of the elite who formed the core of patrons of British art changed, and the kind of self-imagery they demanded changed too. The domestic portraiture of the eighteenth century, especially the small-scale 'conversation piece', gave vivid expression to this shift in values, embodying the more informal codes of social distinction, whose rules could encompass the newly wealthy alongside the old aristocracy and gentry. In the place of elaborate and artificial symbolism, and the more ostentatious displays of personal wealth and status, a more naturalistic portraiture appeared, which proclaimed the sitter's worth as a private person. What has seemed to modern eyes the epitome of natural grace, eighteenth-century British portraiture from Hogarth to Reynolds and Gainsborough also provides a highly refined index to contemporary social, sexual and ethnic discrimination.

With the emergence in the later eighteenth century of the concept of 'sensibility' (the idea that society was held together by emotional rather than strictly hierarchical political or financial bonds) a more deliberately emotive and intimate (though just as highly conventionalised) stylisation of the individual emerged. This view is apparent in Romney's touching *Mrs Johnstone and her Son* (p.45). Still, the role of portraiture within courtly rituals found an echo within the marriage market of the later period, where grandly beautifying images of women were essentially advertisements of sexual allure and social worth. Perhaps the most grandly conceived example, Reynolds's *Three Ladies Adorning a Term of Hymen* of 1773, is illustrated here (p.46).

Portrait painting remained an important genre throughout the nineteenth century, and still today there are artists working in traditions of portraiture stretching back to Van Dyck. If social attitudes to appearance and the status of painting itself have been challenged recurrently throughout the twentieth century, there have nonetheless been highly innovative achievements in the field of portraiture, from David Hockney's *Mr and Mrs Clark and Percy* (p.126) through to more confrontational images like Lucian Freud's *Girl with a White Dog* (p.114) or, even, Francis Bacon's *Seated Figure* (p.116). The nihilistic glamour of Bacon's disrupted imagery of humanity on the edge of (literally) breaking apart in bleak isolation has offered an emblem of the greatest anxieties of the twentieth century, that admits little in the way of amusing anecdote or narrative complexity. Yet his work sits within and responds to the tradition of richly painterly portrait images.

In the field of subject painting, public and family life have provided the raw matter for moralising and comic imagery, a genre forged by the eighteenth-century painters of modern-life subjects, notably Hogarth, and brought to a peak during the nineteenth century. The emergence of new work patterns, increasing calls for women's independence and a loss of faith in religion and in the traditional political and economic systems meant that issues of public and private morality were hotly debated in the Victorian era. Many artists were preoccupied with images of the family and the domestic sphere, whether in idealised form or, more often, corrupted and disrupted by immorality and vice. Characteristically, these pictures would convey a story through telling details drawn from everyday life. In the work of the Pre-Raphaelite Brotherhood and their imitators and followers, the canvas is typically crammed with minutely observed household objects or flora and fauna that were intended to carry enormous symbolic weight. Yet one senses an almost excessive effort to make observation the vehicle of moral meaning. Holman Hunt's *The Awakening Conscience* (p.74), for instance, is so overloaded with detail that it creates, perversely, a sense of unease about the reality of objects that can be read as a distillation of the discordant sensationalism of modern urban life.

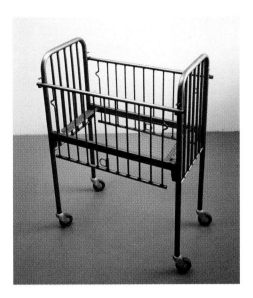

Mona Hatoum
born 1952

Incommunicado
1993
Metal cot and wire
126.4 x 57.5 x 93.5 cm

The artist has transformed a cot, a symbol of domestic safety, into a physically threatening object. Instead of a mattress, the cot has taut wires, and the metal bars are left cruelly bare.

This very uncertainty emerged as a central preoccupation in the 'problem pictures' of the later nineteenth century, such as Orchardson's *The First Cloud* (p.92), which depicts a family drama, but in deliberately elusive terms which leaves the viewer guessing what the outcome would be. For Sickert, an artist who is now seen as marking a pivotal moment between the relative (and self-deluding) certainties of Victorian visual culture and the heady multiplicity of modernity, there is at once an overwhelming desire to tell stories, and a tentativeness and ambiguity in his means of picturing those stories which undermines the power of painting as a kind of illustration. His *Ennui* (p.93) suggests enough of a story for Virginia Woolf to have imagined a whole narrative, but the relationship between its protagonists must remain a mystery.

If storytelling, and the theme of the domestic, have been relatively marginal in much avant-garde art of the twentieth century, more recently they have re-emerged with a vengeance. Many living artists in Britain are particularly interested in publicly exploring issues of morality, sexuality and truth, but without taking a moral high-ground, and without providing an explicit commentary. Their willingness to use the raw artefacts of 'real life' as the subject and material of their art also hints at a bigger, forgotten history of objects. For the vast majority of people in Britain in history, the visual arts infiltrated domestic life in forms that have largely been excluded from the Tate's collection: homemade or locally made artefacts and cheap reproductions which were so negligent of the aesthetic standards demanded by established taste that they have been categorised as anthropological or 'social history' artefacts rather than 'art'. The refined and exclusive portraits and domestic scenes that have been given a public home in the Tate collection offer a rich view on humanity, but only ever a very particular view.

Samuel Palmer
1805–1881

A Hilly Scene
c. 1826–8
Watercolour and gum arabic
on paper on mahogany
20.6 × 13.7 cm

Palmer's highly personal views of
the English landscape were infused
with a sense of religion and mystery.
Here, the church and the Gothic
arch formed by the trees are
intended to create a spiritual
atmosphere.

Literature and Fantasy

According to a well-worn myth about British art, the national culture has always been orientated towards literature rather than the visual arts. The cultural achievement of 'our nation' has purportedly been in the hands of Shakespeare, Milton and Wordsworth, rather than those of painters and sculptors. While the evidence presented by this selection of images must force us to check that assumption, it is nonetheless true that British artists have recurrently turned to textual sources for their subject matter, and that in so doing, have helped give literature a crucial role in defining the different national cultures. Furthermore, this has often had a spiritual aspect. Whilst the established Church has been an inconstant (if not negligible) patron of the visual arts, personalised, even eccentric, interpretations of religion have been apparent in William Blake's symbolic art (p.66), Samuel Palmer's spiritually infused vision of landscape (above), and, in the twentieth century, in the religious paintings of Stanley Spencer (p.106) and the sculpture of Jacob Epstein and Ronald Moody(pp.112, 113). In our own time, a new openness to spiritual experience, tied to more specialised and academic investigations into the nature of bodily experience and the body as a social and psychic entity, has awakened artists to the potential of a mystical, yet concrete, sense of being.

The Reformation long provided a convenient historical explanation for the paucity of 'high art' based on literary and religious sources, which on the Continent was supported by the powerful princes and the Catholic Church. Yet an alternative, no less ambitious in its intellectual scope, nor less intricate in its symbolism, did emerge, in the graphic illustration of the eighteenth century, and in Hogarth's paintings of modern London. Hogarth's alternative to high art relied on a vital dialogue between art and the social reality

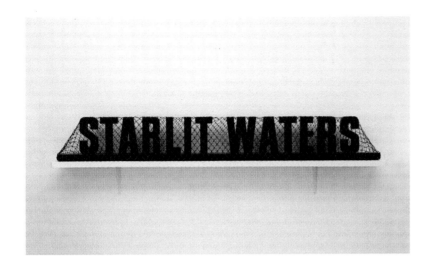

Ian Hamilton Finlay
born 1925

Starlit Waters
1967
Painted wood and
nylon fishing net
31.1 x 240 x 13.3 cm

Finlay is a poet, who uses words as
physical objects in different visual
settings. Here, a deliberately poetic
phrase is isolated and presented as
a starkly minimal sculptural artefact.

of the time, and he drew his sources from the life of the metropolis as retold in plays, musicals and popular publications (see p. 38). His prints and paintings emerged out of a crucial turning point in the history of Britain's visual culture, when a wider, less exclusive public for art was beginning to grow and influence the kinds of imagery artists produced. Where once the display of art was basically restricted to the wealthiest homes, from the end of the seventeenth century a more extensive market for paintings and prints developed, especially in London. If the classical heroes and goddesses who populated what was defined as 'high art' could be significant for only a tiny minority of British people – effectively, the rather small subsection of the aristocracy and nobility who had both a genuine enthusiasm for visual art and the formal education needed to appreciate its often obscure subject matter – literary subjects did increasingly have a mass market. At the end of the eighteenth century, the ever-widening popularity of English literature was exploited by entrepreneurs, notably John Boydell, who commissioned art intended for mass-reproduction and distribution to a broader public. The paintings of Shakespearean subjects by James Barry and Henry Fuseli illustrated here were produced for Boydell (see pp. 60, 61). In the Victorian era, the public for art expanded enormously, and artists such as Millias and Waterhouse used literary sources (see pp. 73, 87) to produce art that was high-minded in tone yet accessible to a relatively large section of the public through major public art exhibitions across the country and high-quality, but now relatively affordable, reproductions.

Much of the new art of the twentieth century rejected 'illustration', following the critical position that works of art could exist as discrete entities in their own right. But while, until recently, artists were generally uninterested in the literary subjects that occupied their antecedents, text, and other forms of

graphic and literary communication, have had important roles as sources of inspiration for, and the very material of, new art. Following the particular example of Marcel Duchamp, the Pop artists of the 1960s integrated text into their images, disrupting the role of painting as a way of representing the world and introducing (sometimes abrasive) commentary. Even the casual observer of the contemporary art scene can hardly miss the centrality of language in art now, whether in aural or graphic form, conjured by light or introduced playfully as a concrete entity in its own right. The return to literary or textual allusions is a characteristic of art in our time, whether the intention is poetic and suggestive, as in Richard Deacon's *If The Shoe Fits* (p. 132), or ironic and questioning, as in Simon Patterson's *The Great Bear* (p. 137).

Home and Abroad

When is an artist British? From Hilliard's long sojourn in France in the late 1570s through to Hockney's move to California in the 1960s, British-born artists have worked in a truly global context, training, exhibiting and living abroad. Although modern media have ensured that the international audience for British art is more evident than ever, artists based in this country have always been known and appreciated further afield (at least as far back as the sculptors in alabaster of the later Middle Ages, who exported their wares across Europe). Equally, Britain has been host to numerous artists born or trained abroad, whether the outstanding talents employed at the royal courts throughout the centuries, or émigrés forced to leave their homelands. Moreover, Irish artists, such as James Barry, are frequently counted as 'British', although strictly speaking they were not, and the definition of regional traditions in England, Wales, Scotland and Northern Ireland, as well as within each of those countries, remains a thorny problem.

Like the culture of Britain more generally, British art has recurrently been shaped through interaction with foreign cultures. During the sixteenth and seventeenth centuries, the visual arts were orientated to Holland and Flanders, while in the eighteenth century the cosmopolitan atmosphere of the Grand Tour to Italy provided a crucible for the reshaping of the visual styles and subject matter favoured by the most ambitious artists. Join to this the prolonged relationship with French and German art in the nineteenth century, and it should be clear that British art has always been a European phenomenon. From the decorative objects and paintings from the Islamic world collected in Britain in the sixteenth and seventeenth centuries, through to the turbulence of American cultural dominance and post-colonialism in the twentieth century, Britain's various international roles as a marketplace, imperial force, asylum and coloniser have had a direct economic and cultural impact on visual art.

Since the emergence of landscape painting as a distinct artistic genre in the seventeenth century, many major British artists have been preoccupied with the depiction of the rural scenery of the British Isles. While landscape painting provides the most familiar image of traditional British painting, in fact the genre has served a variety of purposes. At the outset landscape imagery was tied to the ideas about property current among the social elite. The undeniable beauty of works by, for instance, Kierincx and Siberechts (see pp. 20, 34) should not distract us from their basic purpose as celebratory records of property, which were intended to be enjoyed by property owners. More resistant to critical interpretation are the celebrated images of an idealised rustic scene by Gainsborough, Turner and Constable (see pp. 42, 64, 65) and the host of artists working in oil or watercolour who made up the so-called Golden Age of British landscape painting from the mid-eighteenth to the mid-nineteenth century. However enticing their vision remains, we may trace in their idyllic visions of rural life a set of very particular claims about Britain, which posits a mythically peaceful countryside as the embodiment of an orderly nation. Moreover, the naturalistic tendency itself ties in with a continuing ideal of British forthrightness and honesty. Constable's attachment to the local scenery of England and his highly original, sometimes strident, painting technique, combined in the minds of many of his supporters to make him the epitome of what it meant to be a painter and to be British (see p. 69).

The greatest landscape paintings retain the power to surprise us with their freshness and vigour. Yet our view of the landscape tradition is still partly filtered through the mythology of a national school of art that emerged in the later nineteenth century. Artists as diverse in their real interests and status as Gainsborough, Constable and Turner were viewed as key figures in the evolution of a kind of naturalism

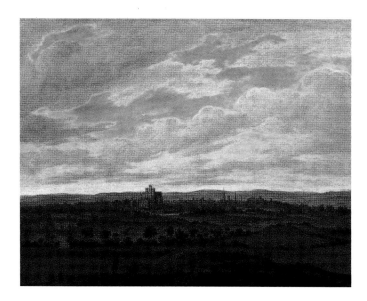

Alexander Keirincx
1600–1652

Distant View of York
1639
Oil on oak panel
52.9 x 68.7 cm

This is one of a series of pictures
showing towns and palaces in the
north of England commissioned
from the artist by King Charles I.
The artist's sensitive treatment
of light and atmosphere underpins
a celebratory vision of the King's
dominion.

that was peculiarly British, while whole regional traditions (notably the Norwich School of painters) were in part invented by local collectors and historians. Again, during the 1920s and particularly the 1930s, when Britain was facing economic crisis and eventually war, the idea of the landscape as the foundation of the best British art emerged as a central idea of art criticism. A number of artists of distinctly avant-garde interests, notably Graham Sutherland and Paul Nash, were promoted on the basis of their combination of modernist pictorial techniques with a clear and deeply felt attachment to the national landscape (see pp.103, 111). In recent decades, the emotional and intellectual resonance of native scenery has been a persistent concern of a number of artists, even when their work has taken on the most challenging forms.

Perhaps an even more significant, and persistent, element of the myth of British art has been the idea of its fundamental diversity and idiosyncracy. This has been one of the sustaining ideas of British culture, brought into play to enforce a sense of personal and institutional integrity at a number of key points in its history. A belief in the individuality of the national character and so of the national school of art was crucial for Hogarth, who saw himself waging a battle against foreign competition and the exploitation of his peers, and crucial again during the middle decades of the twentieth century, when the avant-gardes of France and then America seemed to dominate the international cultural stage at the expense of all else. Art history has often stressed the idiosyncrasy of British art, particularly the failure of British artists to assume in a wholehearted way the artistic ideologies pursued more dogmatically abroad (late eighteenth-century Neo-Classicism being a prime example), an idea that has a close analogy in longstanding beliefs about the fundamentally moderate character of British political life. In our own time, the history of British art in

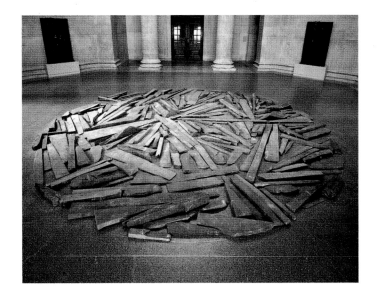

Richard Long
born 1945

Slate Circle
1979
Slate

Long's works are developed out of his personal experience of the landscape. The slates that make up this piece come from a quarry in Wales that the artist visited on one of his walking tours.

the twentieth century has been written to privilege a few outstanding talents whose prime characteristic would seem to be their alienation from the mainstream of continental modernism – including Stanley Spencer, Francis Bacon, and Lucian Freud (see pp. 105, 114, 116). In recent years, discussions of 'Young British Artists' have often stressed their abrasive individualism. The idea of eccentricity has been vital to successive generations of British artists but it does not mean that their story is simply eccentric, nor a question of individual personalities, but rather one of constantly changing conditions of artistic production that facilitated, challenged and reformulated the terms of artistic expertise and expression. Unthinkingly affirming the vital diversity of British art may be only to reaffirm one of the most comforting myths of Britishness, and dull our real appreciation and enjoyment of art in Britain. On the other hand, confronting that very myth, and accepting the full diversity of history as an opportunity to explore historical, personal and social meanings may be particularly enriching. But that is not the task of art historians and curators alone (although we claim it as our privilege): rather, it is for everyone who chooses to look again at British art.

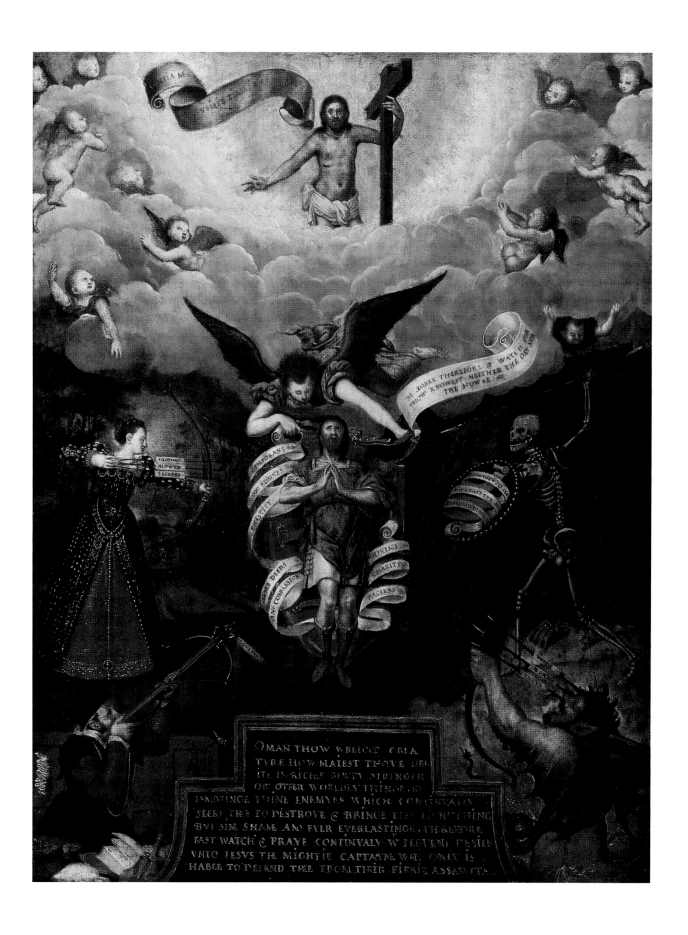

British School

Sixteenth century

An Allegory of Man

c. 1596

Oil on wood

57 x 51.4 cm

This work is a rare surviving example of British religious painting of the sixteenth century. The introduction of the Protestant Reformation of the mid-sixteenth century has traditionally been considered as a cataclysmic rupture in the history of Britain's visual arts, resulting in the destruction and sale of the Church's property, including sculpture and paintings, and an effective prohibition on images in places of worship. Recent research suggests that iconoclasm (the destruction of images) was not as complete or final as has often been thought, and that early images were lost over a prolonged period well into the seventeenth century. Documentary evidence shows the widespread ownership of pictures for private use, including religious imagery. This painting may have been made for a private chapel or funerary monument, and its symbolism is related in English and Latin texts painted on its surface. It shows Man, the central figure, assailed on all sides by Death and the Seven Deadly Sins. An angel holding a shield of Christian Virtues protects him, and Man's ultimate salvation is suggested by the figure of Christ in the top section of the picture. The identity of the painter is not known: we know the names of few artists working in Britain at this time.

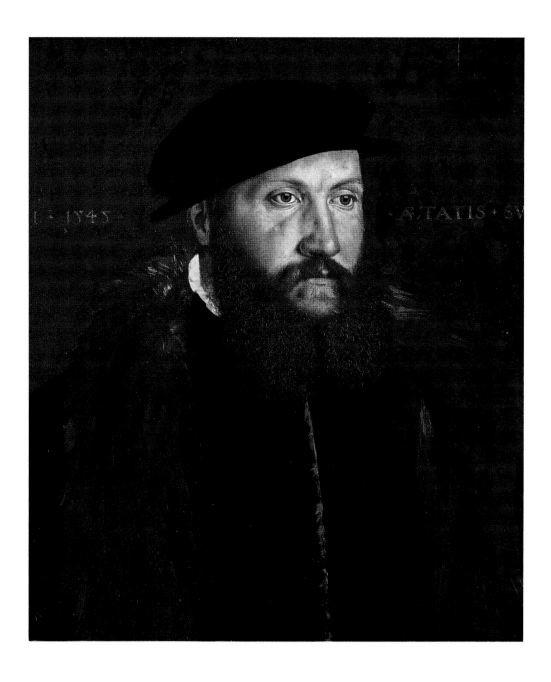

John Bettes

active 1531–1570

**A Man in
a Black Cap**
1545
Oil on oak panel
47 × 41 cm

This is the earliest painting currently in the Tate's collection, and probably the earliest surviving easel painting signed by an English artist. John Bettes is known from a handful of works. First recorded as painting decorations at Whitehall in the 1530s, he raised his status as an artist through assuming the manner of Hans Holbein the Younger, the German painter who worked at the court of Henry VIII. This work resembles Holbein's in its precise treatment of the sitter's features and the illusion of three-dimensional solidity given to the figure. The background to this portrait has degenerated to a brown colour, having originally been deep blue, in common with North European portraits of this period. The picture is particularly important in demonstrating the adoption by a native-born artist of the modern style practised in Italy and Northern Europe, so furthering the efforts of the English court to enter the mainstream of Continental culture.

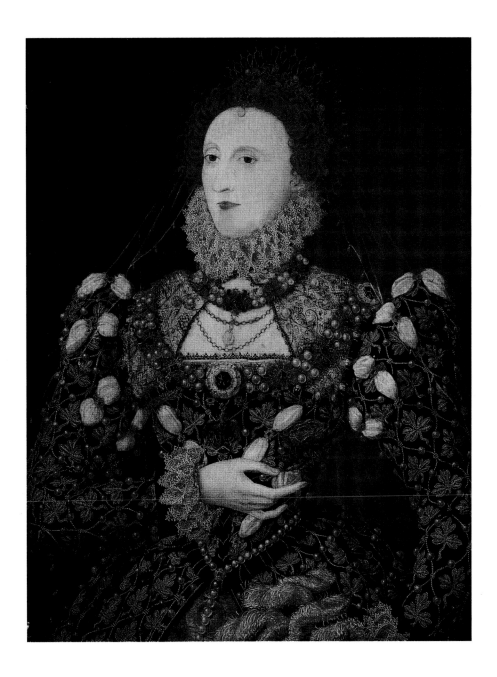

attributed to Nicholas Hilliard

c. 1547–1619

Queen Elizabeth I

c. 1575

Oil on wood

78.7 × 61 cm

The severe decorative flatness of this portrait is typical of contemporary images of Queen Elizabeth I. Although this flatness gives the work an old-fashioned, even medieval appearance compared to the work of Holbein and his imitators, this was a deliberate means of conveying the austere public image of the female monarch. The attribution to Hilliard, who is best known for his miniatures, is based on similarities between this work and a miniature known to be by him. This painting conveys much of the jewel-like quality found in his miniatures. The richness and glitter apparent in the painting of Elizabeth's costume has a sensual quality absent from the stern portrayal of the queen herself. As a woman in a role conventionally described in patriarchal terms, Elizabeth had to work hard at maintaining her authority, and images of her downplayed her physicality and sexuality.

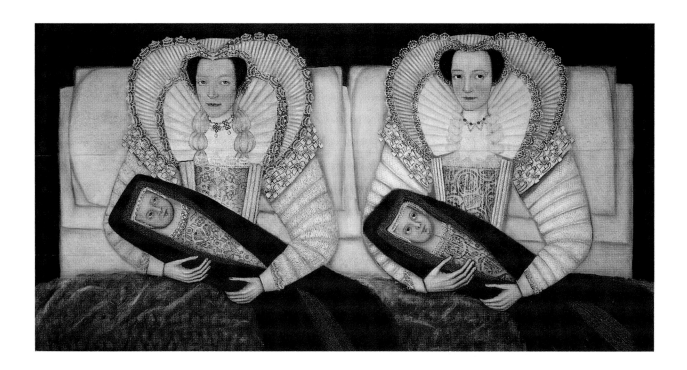

British School

Seventeenth century

**The Cholmondeley
Ladies**
c. 1600–10
Oil on wood
88.9 × 172.7 cm

This painting, believed to date from the first decade of the seventeenth century, remains something of a mystery. It shows two elaborately dressed women sitting upright in bed, each holding a baby wrapped tightly in red christening clothes. It is not known who painted it or precisely why, but an inscription to the bottom left of the painting provides some illumination. It reads: 'Two ladies of the Cholmondeley Family / Who were born on the same day / Married on the same day / And brought to bed [i.e. gave birth] on the same day'. However, this inscription was added at a later date – perhaps during the eighteenth century. The painting probably does represent members of the Cholmondeley (pronounced 'Chumley') family of Cheshire, as it once belonged to a descendant. The close resemblance of the two women suggests that they are meant as sisters, although examination reveals that they are not identical: their eyes are different colours. The formality of this image refers to aristocratic tomb sculpture of the period, which has a similar stiffness and symmetry in its presentation of the human figure.

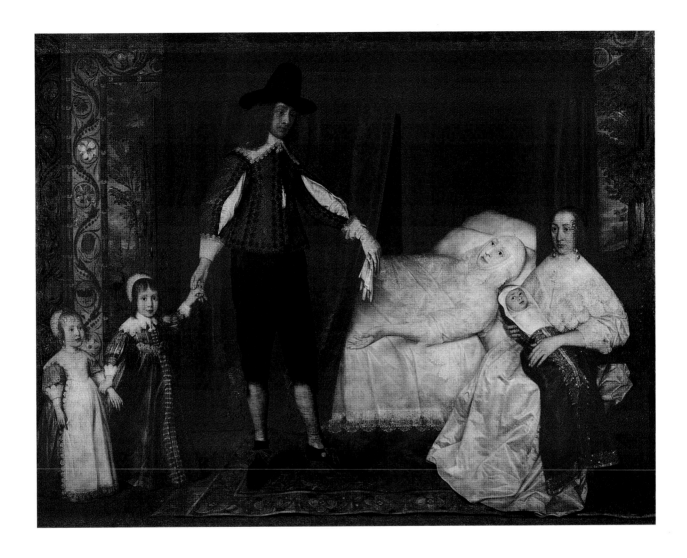

**David
Des Granges**
1611 or 13–?1675

**The Saltonstall
Family**
c. 1636–7
Oil on canvas
214 × 276.2 cm

The Guernsey-born David des Granges was a miniature painter, and this large-scale oil painting by him shares many of the characteristics of painting 'in small', including the naturalistic treatment of the portraits and the intimate subject matter. It is believed to depict Sir Richard Saltonstall (1595–1650) with members of his family. The exact relationships between the figures remain mysterious. Although it may appear that Sir Richard is introducing his son and daughter to their new sibling, held by a nurse seated by the bed, this does not tie up with the known details about Saltonstall's family life and the seated woman is too well dressed to be a servant. The woman in the bed is probably Saltonstall's first wife, who had died in 1630. The seated woman is likely to be Sir Richard's second wife, Mary, whom he had married in 1633 and who gave birth to sons in 1634 and 1636. The depiction of living and dead relatives and spouses within a single image was found in tomb sculpture of the time and was a means of presenting their dynastic relationships in explicit visual form. Despite the emotive subject matter, this painting would have served as an elaborate documentation of family ties and bloodlines.

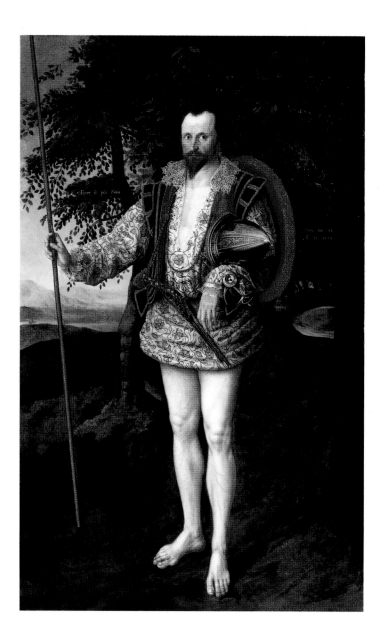

Marcus Gheeraerts the Younger
1561 or 2–1636

Portrait of Captain Thomas Lee
1594
Oil on canvas
230.5 × 150.8 cm

This unusual portrait depicts the English gentleman Sir Thomas Lee, barelegged and bare-chested in the style of the rather fantastical book illustrations of ordinary Irish foot soldiers of the time. Lee was a troop commander in the English army that colonised Ireland in the late sixteenth century, but at the time this portrait was painted he was under suspicion for treason against Elizabeth I. Probably produced as a statement about Lee's political position, the image is loaded with symbolic and punning references. A Latin quotation on the canvas associates Lee with the ancient Roman hero Gaius Mucius Scaevola, and he stands in the shelter or 'lee' of an oak-tree, a traditional symbol of constancy. At the same time, the picture is a bold statement of Lee's physical presence. The figure's association with the lowly Irishman, then considered barbaric and foreign by the English, his partial nakedness, and his martial equipage, create a vivid image of athletic manliness. Nudity was considered as appropriate in heroic male portraits, and here conveys a sense of reckless manliness then seen as part of the personal make-up of the ideal gentleman.

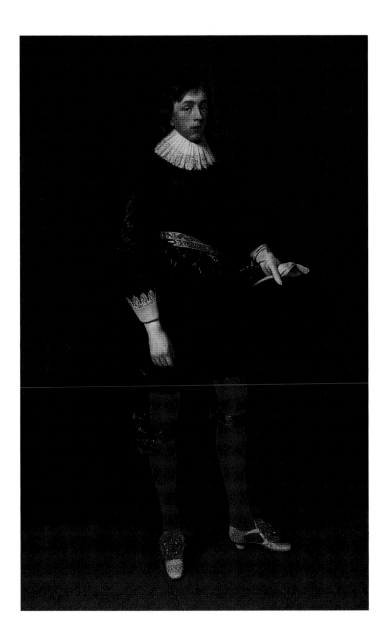

Daniel Mytens
the Elder
c. 1590 – c. 1647

**Portrait of James Hamilton,
Earl of Arran, Later 3rd Marquis
and 1st Duke of Hamilton,
Aged 17**
1623
Oil on canvas
200.7 × 125.1 cm

During the early seventeenth century, King James I and then King Charles I employed a series of outstanding foreign artists to work at their courts, including the Dutch artist Mytens, establishing England as a real cultural presence on the European scene for perhaps the first time. This portrait depicts James Hamilton, a young Scottish aristocratic who was an associate of the future Charles I. Hamilton had recently returned from Spain, where he may have seen the works by the Spanish court artist Diego Velásquez, which this work resembles in its stark format and elegant, painterly qualities. The black costume and simplicity of the image as a whole embody the ideal of the gentleman current in European court culture of the period, although the look was novel in England. Where earlier generations displayed their status through showy jewellery and dress, or elaborate allegorical devices, here the sitter's rank is expressed primarily as a matter of deportment and natural modesty, qualities reinforced by the sophisticated character of Mytens's painting.

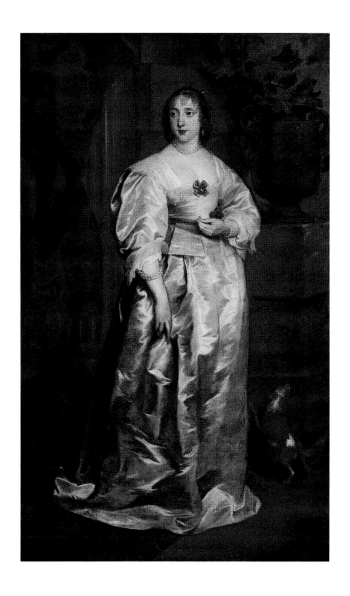

**Anthony
Van Dyck**
1599–1641

**A Lady of the
Spencer Family**
c. 1633–8
Oil on canvas
207.6 × 127.6 cm

The Antwerp-born artist Van Dyck was the
leading portrait painter working for Charles I
during the 1630s. His portraiture was particularly
successful in contriving a sense of natural
elegance for his sitters. Here, although we are not
certain of the sitter's identity, we are provided
with an image of dignity and glamour then
considered to be the exclusive privilege of the
land-owning elite. She has traditionally been
referred to as a member of the aristocratic
Spencer family (the ancestors of the late Diana,
Princess of Wales) and the picture was first
recorded in the family collection as early as the
eighteenth century. The dog in the bottom right-
hand corner of the picture is a symbol of fidelity,
suggesting that the picture may represent a newly
married woman. However, this symbolic feature
appears entirely natural, and it is the physical
presence of the sitter that takes precedence –
ensuring that her superior social status appears
to derive naturally from her bearing and beauty,
rather than being 'spelled out' in symbolism.
Van Dyck's flashy but elegant compositions
formed a model for many later portrait painters.

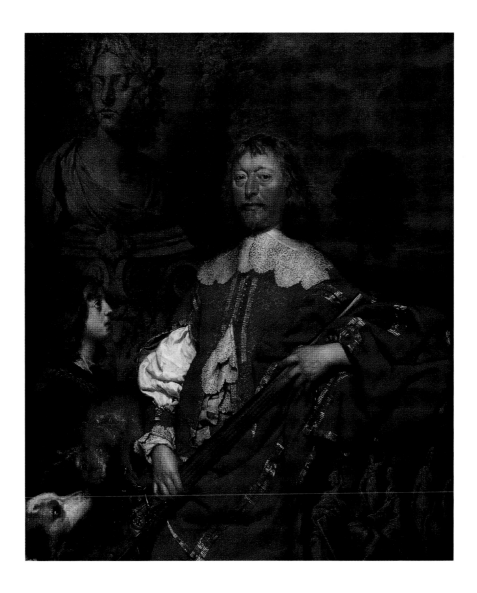

William Dobson

1611–1646

Endymion Porter

c. 1642–5
Oil on canvas
149.9 × 127 cm

William Dobson was the main English painter of the aristocratic classes during the period of the English Civil War. Here, his depiction of Endymion Porter (1587–1649) draws attention to his sitter's achievements as an intellectual, sportsman and courtier. The bust to the top left is of Apollo, the Greek god of the arts, which may refer to Porter's activities as an art adviser to Charles I. In contrast, Porter is dressed in hunting clothes, holds a rifle and is presented with a hare by a pageboy, all references to gentlemanly country sports. The frieze to the bottom right depicts the production of a figure of Pallas Athene, Greek goddess of art, science

and war, so indicating the full range of Porter's supposed qualities. The background landscape establishes a bucolic tone for the image and refers to the usual source of aristocratic wealth – land ownership. Although this work was produced at the time of the Civil War, Porter took no active role in the conflict. Rather, he settled in Charles's exiled court at Oxford, where this picture was painted. The relaxed confidence Dobson shows in Porter may suggest an ideal of genteel stability detached from actual events, although given its context it is natural to look for signs of stress and anxiety in the picture.

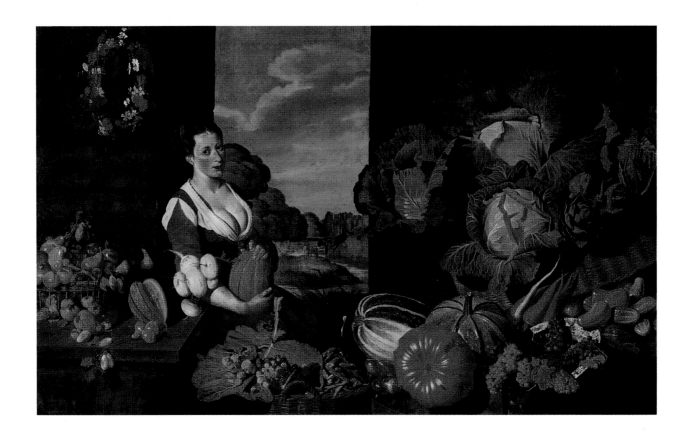

Nathaniel Bacon

1585–1627

Cookmaid with Still Life of Vegetables and Fruit

c. 1620–5

Oil on canvas

151 × 246.7 cm

The depiction of a bountiful display of agricultural produce is a common feature of seventeenth-century still-life paintings (pictures of inanimate objects). Often the fruit and vegetables were shown together to represent a month or season. In this case the produce would have been in season at different times of the year, highlighting the contrived nature of the image. In a more general way, the picture is about the theme of fecundity in nature, with the voluptuous figure of the female servant being exploited to reinforce that theme (the visual analogy between her breasts and the melon she holds being all too obvious). Sir Nathaniel Bacon was an English gentleman and practised art only as an amateur. He is known to have painted many still lifes, which show his knowledge of contemporary Dutch and Flemish artists, who were the leading practitioners in this genre. Bacon would have seen such paintings when he travelled in Holland and Flanders. He was also a keen horticulturist, and we know that he was growing melons on his own estate in Norfolk in the 1620s.

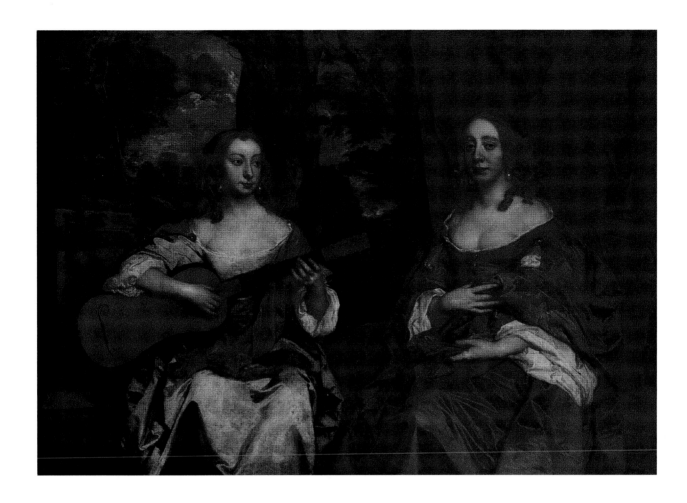

Peter Lely

1618–1680

**Two Ladies of
the Lake Family**

c. 1660

Oil on canvas

127 × 181 cm

Lely was the leading portrait painter working at the English court in the 1660s and 1670s. His success was based on his ability to flatter his sitters with portraits notable for their voluptuous evocation of colours and textures and their tone of arch elegance. This portrait is typical of his work of the 1660s, when his painting technique was at its most lush and liberated. The sitters have not been identified, and without documentary evidence it is unlikely that they will be, as the features of all Lely's women tend to conform to an impersonal standard of beauty. Like other images of courtly women of the seventeenth century, the picture is more concerned with asserting the glamour and (perhaps vacuous) sophistication of the sitters than with establishing a sense of individual personality, or even appearance. As one early commentator remarked of Lely: 'all his pictures had an Air one of another, all the eyes were sleepily alike'.

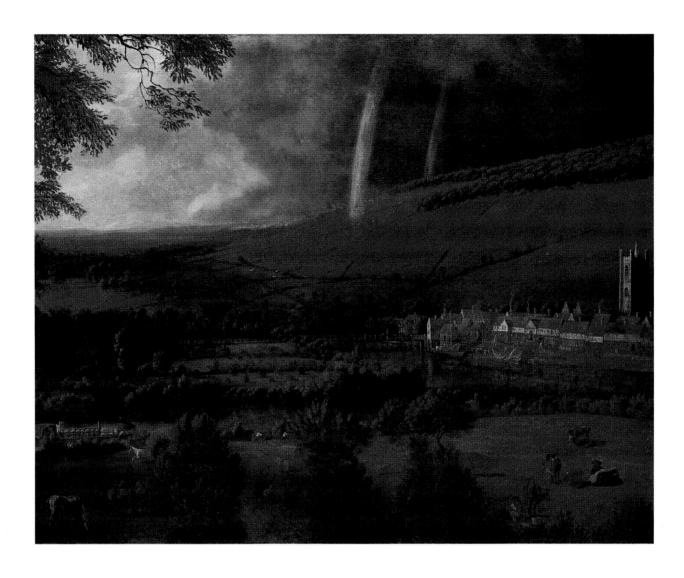

Jan Siberechts
1627–c.1700

**Landscape
with Rainbow,
Henley-on-Thames**
c.1690
Oil on canvas
81.9 × 102.9 cm

The last decades of the seventeenth century saw the emergence of landscape painting as a genre in its own right in Britain. Jan Siberechts was one of the many artists who came from Holland and Flanders to practise their art in England. He was primarily occupied with painting scenes of country houses and the surrounding landscape, which owners commissioned from him as a way of recording and accentuating the beauty and extent of their property. Unusually, this example of Siberechts's painting focuses on the village of Henley-on-Thames, outside London. The rainbow and passing shadows that fall over the land conjure a sense of temporality and evoke a strong feeling of a particular place. While the picture speaks of the love of nature that was to become such a central component of British national identity, Siberechts's work also reminds us of how landscape painting owed its origins and development to the personal aspirations of wealthy landowners.

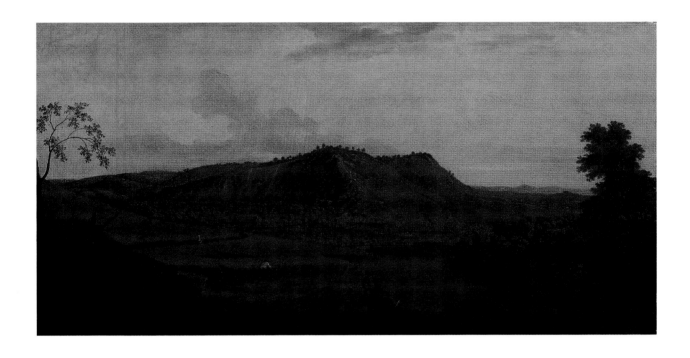

George Lambert
1700–1765

A View of Box Hill, Surrey
1733
Oil on canvas
90.8 × 180.4 cm

George Lambert was the most important native painter of landscape in the early eighteenth century. He painted idealised landscapes that referred to the Italian landscape and the antique past, and recognisable English scenes. This picture shows a view of Box Hill in Surrey, in the south of England. Although composed in a highly balanced and ordered way, like his classical landscapes, Lambert's picture conveys a strong sense of a real place. The three figures in the foreground are a significant detail. Their costume identifies them as gentlemen, and their postures and the discarded wine bottle reveal how Lambert wanted to depict them relaxing while surveying the surroundings. Articulating an aestheticised ideal of the English landscape current among the wealthy classes in the eighteenth century, the picture presents labourers and gentlemen each feeling at ease taking up their different roles in the natural world. The balance and order of art thus infers balance and order in the world of the landed elite.

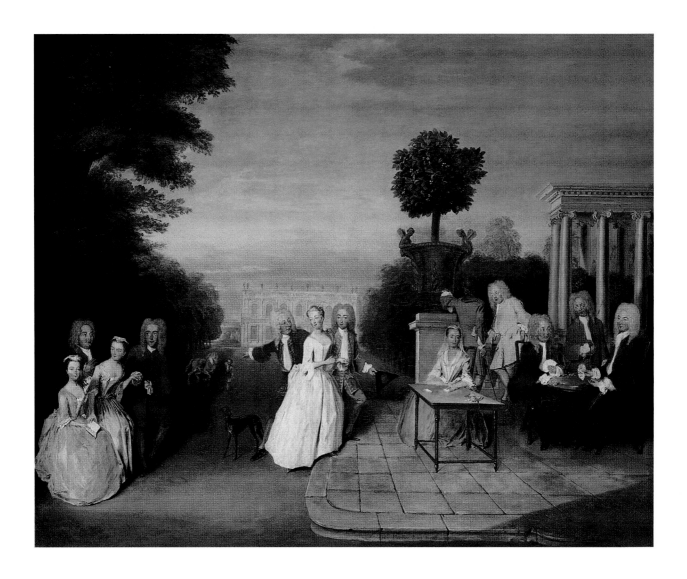

Philip Mercier
?1689–1760

**The Schutz Family
and their Friends
on a Terrace**
1725
Oil on canvas
102.2 × 125.7 cm

This is an early example of a 'conversation piece' painted in Britain. The conversation piece was a group portrait on a small scale, showing family and friends posed informally as if interrupted during conversation or engaged in some playful activity. The popularity of the genre indicates an important change in genteel self-presentation in the early eighteenth century, when ostentatious displays of wealth and rigid rules regarding pose and gesture were replaced by a new emphasis on the natural and unpretentious. As a pictorial form, the conversation piece derived from Flemish and Dutch traditions, but more particularly from the paintings of the French artist Antoine Watteau.

Mercier, who trained as an artist in his native Germany, had travelled in France and knew Watteau's work. Coming to England in 1715, his paintings found favour with Frederick, Prince of Wales and his courtiers, who were looking for alternatives to the more frigid kinds of portraiture that were then the convention. The identity of the family in this painting remains mysterious; it has traditionally been associated with the Schutz family, Germans based in England and closely connected with the court. The painting includes a number of symbolic elements, such as the white horse, which may offer clues to the exact identity of the sitters.

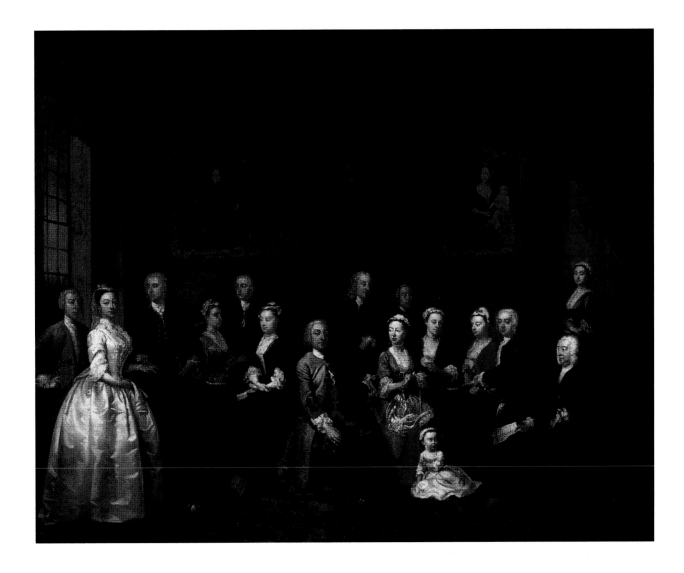

Gawen Hamilton

*c.*1698–1737

The Du Cane and Boehm Family Group

*c.*1734–5

Oil on canvas

101.6 × 127 cm

The Scottish artist Gawen Hamilton was one of the most successful painters of conversation pieces based in London during the 1730s. This picture depicts members of the Du Cane and Boehm families, leading bankers and members of London's Huguenot (exiled French Protestant) community. The two families were united in 1730 by the marriage of Charles Boehm and Jane Du Cane, who are shown seated together in the foreground. The painting thus serves to present a dynastic vision of these wealthy families – which extends to include the old family portraits hanging on the wall at the back, and the posthumous depiction of Clement Boehm (died 1734) seated on the right-hand side of the picture, holding his will. Although also derived from the model of Watteau in its scale and informal groupings, the painting can be distinguished from the conversation pieces produced by Mercier in its more sober colouring and chalkier painting technique. Like his contemporary and rival William Hogarth, Hamilton's robust, if sometimes rather inelegant, style of painting seems particularly to have appealed to patrons outside court circles.

William Hogarth
1697–1764

A Scene from
The Beggar's Opera
1731
Oil on canvas
57.2 × 76.2 cm

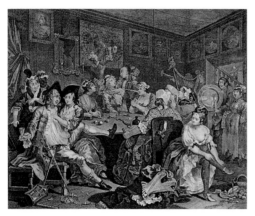

William Hogarth, *A Rake's Progress (plate 3)* 1735
etching and engraving on paper 31.8 × 38.7 cm

This early painting by Hogarth shows the climactic scene from a performance of John Gay's contemporary musical play, *The Beggar's Opera*. The setting represents Newgate Prison, where the anti-hero, the convicted highwayman and bigamist MacHeath, is shown standing in chains between his wives Lucy and Polly. Both women plead for his life. The figures at either side of this group are not actors in the play, but the wealthiest members of the audience who at this time usually sat on the stage. Hogarth plays with the ambiguity this entails, connecting the gaze of the actress Lavinia Fenton, who plays Polly, and the Duke of Bolton, seated on the far right; the couple were beginning a scandalous love affair at this time. Like Gay's play, Hogarth's picture parodied elements of more traditional, 'high' art; for instance, MacHeath is posed to look like Hercules, choosing between Virtue and Pleasure. In painting a subject from a popular play by a living English writer, Hogarth was appealing to the newly developing metropolitan market for art, which he subsequently exploited more successfully with his series of mass-produced prints showing invented comic scenes from contemporary life, such as *A Rake's Progress*.

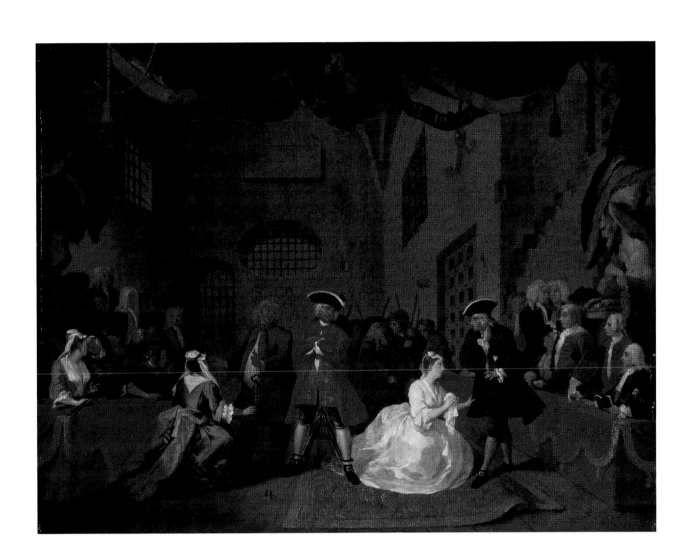

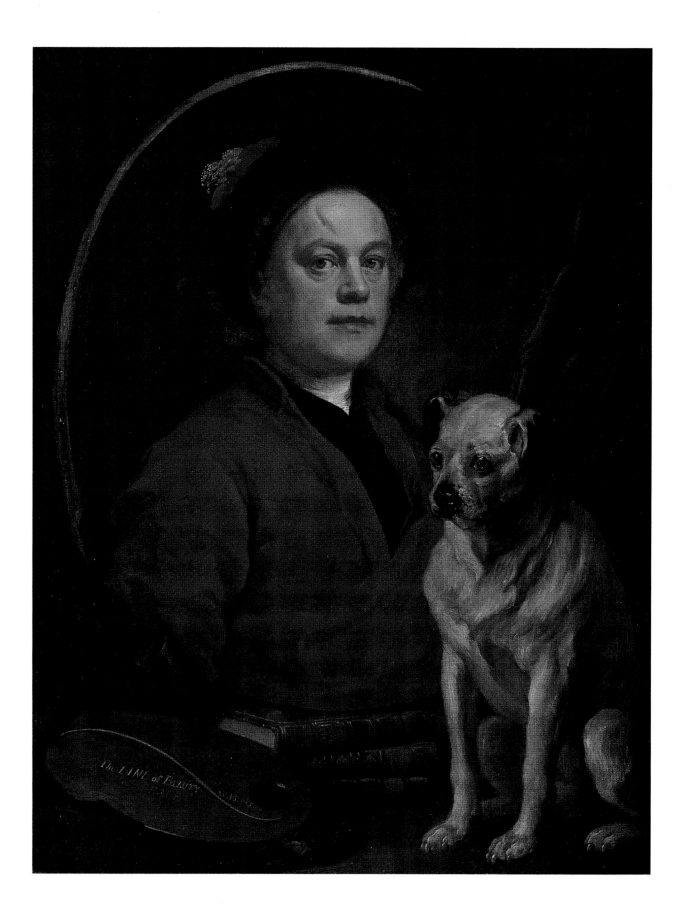

William Hogarth

1697–1764

**The Painter
and his Pug**
1745
Oil on canvas
90 x 69.9 cm

By the time he painted this self-portrait at the
age of forty-eight, Hogarth was well known
across Europe through the printed reproductions
of his comic but moralising pictures of modern
life. The self-portrait presents a complex and un-
conventional image of the artist. The complexity
begins with the depiction of the portrait as
a 'real' object within a still life rather than as
a portrait taken directly from life. The visual
analogy between Hogarth's features and those of
his pet dog, Trump the pug, suggests the painter's
'pugnacious' character. He is shown without a
wig (gentlemen would usually be shown with
their wig on) and with a prominent scar above
his right eye, reinforcing this rough-and-ready
image, quite different from that of other artists
who mimicked upper-class lifestyles. Yet the
picture also stresses the artist's intellectual aspects,
with his portrait resting on volumes by Swift,
Milton and Shakespeare, and the puzzling 'Line
of Beauty' drawn on the palette. For Hogarth,
painting was 'a complex form of writing', and
should be full of the robust playfulness which
he claimed characterised British culture. He later
theorised this approach, and the 'Line of Beauty',
in his book, *The Analysis of Beauty* (1753).

**Thomas
Gainsborough**
1727–1788

Wooded Landscape
with a Peasant
Resting
c. 1747
Oil on canvas
62.5 x 78.1 cm

This is a youthful work by Gainsborough, undertaken shortly after he had first established his own studio in London. In its detailed treatment of foliage, orderly composition and subtly luminous light, its shows a debt to the example of Dutch landscape paintings, which were very popular with British art collectors. In these respects, it represents a challenge to the dominance of more exclusive Italian models for landscape painting, and a new sense of naturalism found also in the figure paintings by Hogarth of the period. Unlike many of his contemporaries, Gainsborough did not travel to the Continent to study art. His work was particularly admired for its apparent informality and naturalism, qualities that were seen as defining a distinctly British way of painting during the mid-eighteenth century, regardless of their roots in the French Rococo art imported by Mercier and Hubert Gravelot, Gainsborough's teacher. At the same time, this idealised vision of the English landscape as a place of solace and rest even for the very poorest of its inhabitants represents a particular political viewpoint that denied the harsh realities of rural life.

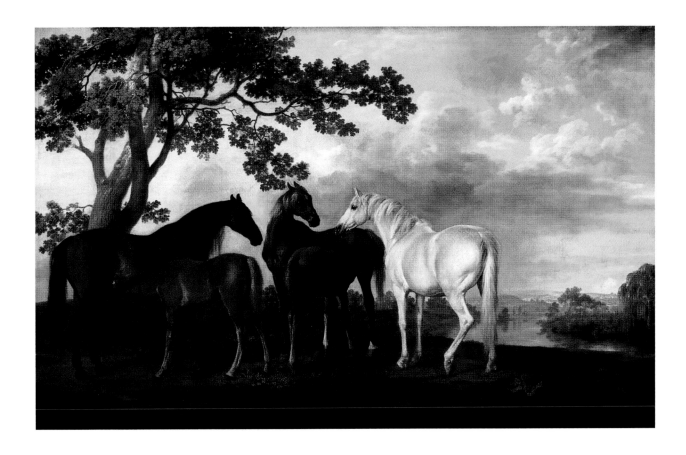

George Stubbs
1724–1806

Mares and Foals in a River Landscape
c. 1763–8
Oil on canvas
101.6 × 161.9 cm

During the 1760s the Liverpool-born painter George Stubbs executed a series of pictures for horse-owning aristocrats showing racehorses or the mothers of famous racehorses with their foals. In this case we do not know the identity of the horses involved, but it is clear that Stubbs wanted to give a strong sense of specificity to the animals. The painter spent years studying the anatomy of horses, and even dissected one himself. He has arranged the animals at different angles to provide a sense of variety and to show off the physique of each, highlighting the relationship between mares and foals and so the perpetuation of healthy bloodlines. We know from other studies by Stubbs that in pictures like this the artist would finish the horses first and then fill in the background landscape. Underlying his precise approach to anatomy and composition was a new appreciation of nature based on reason and measurement that formed part of the intellectual Enlightenment of eighteenth-century Europe.

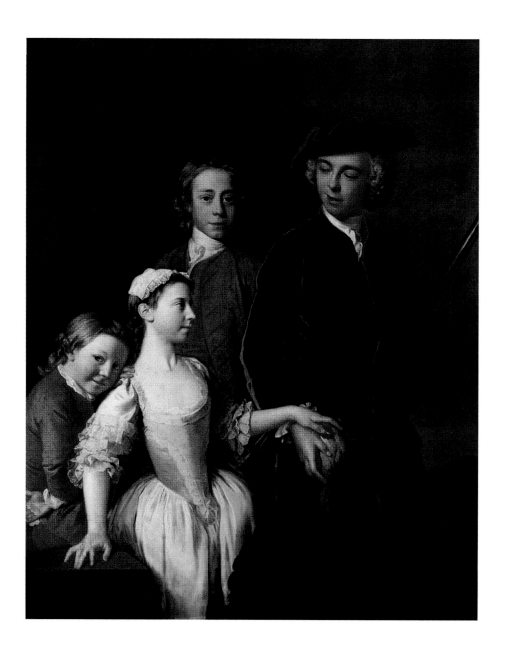

Allan Ramsay

1713–1784

Thomas, 2nd Baron Mansel of Margam with his Blackwood Half-Brothers and Sister

1742

Oil on canvas

124.5 × 100.3 cm

Ramsay was the most successful portrait painter of his generation, maintaining a high-profile career in London and Edinburgh. This painting shows the children of the recently deceased Anne Blackwood, with the son from her first marriage, Thomas Mansel, holding the gun and dead game. The varied poses of the figures, complex interlocking compositional forms, and high finish of the painting shows a debt to the sophisticated art of the Continent, rather than the more prosaic products of native English and Scottish painters of the time. This painting may have been produced as a kind of memorial to Anne Blackwood. The curious relationship between the daughter and her half-brother Mansel – the position of their hands suggests a marriage image – provides an unsettling psychological edge to the picture. Certainly, these two young people are cast into adult roles: the son being the manly sportsman, the young girl being precociously feminine and graceful.

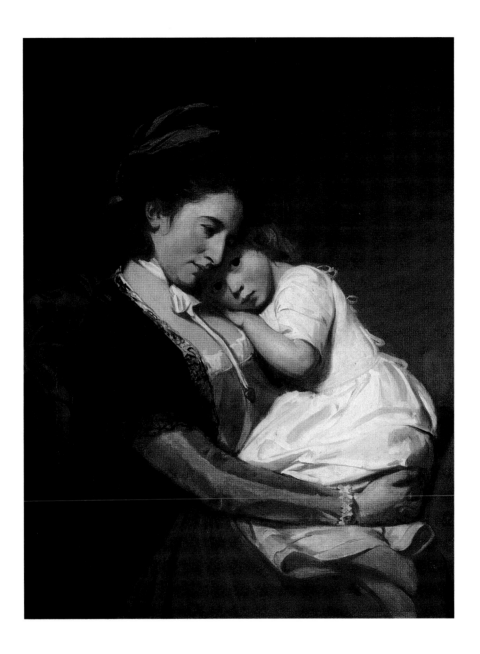

**George
Romney**
1734–1802

**Mrs Johnstone
and her Son (?)**
c. 1775–80
Oil on canvas
89.5 × 70.5 cm

The portrait painter George Romney was especially highly rated for his glamorous depictions of women and children. This painting, identified as a portrait of Mrs Johnstone and her son on the basis that we know it was owned by her grandson, is typical of late eighteenth-century images of settled domestic life, exemplified in the emotional bond between mother and child. While redolent of the tradition of religious imagery focusing on the Madonna and Child, the intimacy apparent in Romney's depiction was relatively new in the late eighteenth century. The idea of 'sensibility' or 'sentimentality', which emerged in popular novels and magazines in the second half of the century, promoted the value of personal emotions and heralded new attitudes towards family life. Romney's sentimental image presents an idealised image of privacy that excludes the references to extended family links and the ostentatious display of wealth and property found in many earlier images of similar subjects.

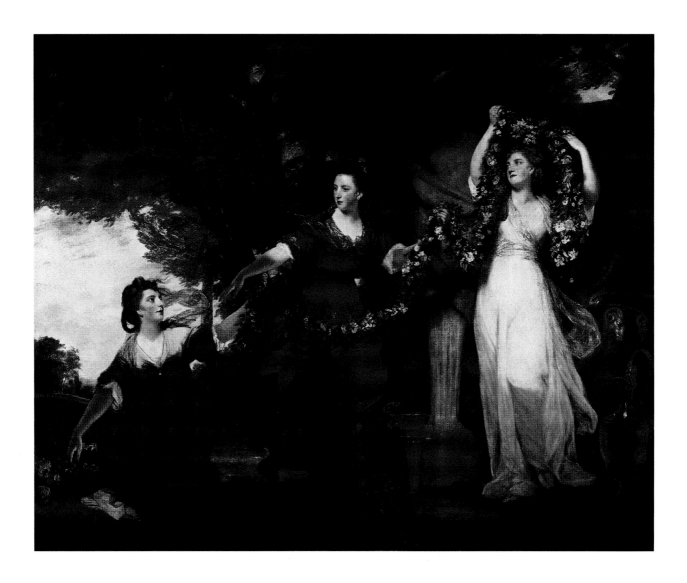

Joshua Reynolds
1723–1792

Three Ladies Adorning a Term of Hymen
1773
Oil on canvas
233.7 × 290.8 cm

This is one of Reynolds's most ambitious exercises in the Grand Style of portraiture, where he would represent his sitters as if they were goddesses or heroines from Renaissance art. The three Montgomery sisters, Barbara, Elizabeth and Anne, Lady Townsend, are shown disposed into elegant postures while dressing a Classical sculpture with flowers. The Irish politician Luke Gardiner commissioned the painting from Reynolds following his engagement to Elizabeth, who is shown at the centre of the image. Elegant portraits of women were often meant to commemorate an engagement or marriage, and were used to celebrate their sitters' worth as wives, potential mothers, and as the sources of income they would become as a result of marriage arrangements. For educated viewers, the picture may have had additional half-hidden meanings. The type of sculpture shown here was associated with ancient fertility cults, while the name of the Greek god of marriage it represents, Hymen, has an obvious significance. The sexual allure of these three young aristocratic women – the fundamental commodity in the elite marriage market of the time – is thus packaged in the guise of Classical allegory. This combination of high culture with basic market instincts was typical of eighteenth-century polite society.

Matthew William Peters
1742–1814

Lydia
c. 1777
Oil on canvas
64.2 x 77 cm

During the 1770s, Matthew William Peters executed a number of erotic subject pictures. This is a version of a painting commissioned from Peters by Lord Grosvenor in 1776. When the original picture was exhibited at the Royal Academy in London in 1777, one newspaper critic claimed to be shocked, and warned that 'every man who has either his wife or daughter with him, must, for decency's sake, hurry them away from that corner of the room'. Pictures with explicit sexual content were quite popular among aristocratic gentlemen in the eighteenth century, although they were rarely as frank as this painting. There was, however, a rapidly developing industry in printed pornographic images that reached a much wider audience. A print after Lord Grosvenor's version of Peters's picture identified the figure as 'Lydia', and included a quote from John Dryden's popular comic play *Amphitryon* (first performed in 1690), providing a literary gloss for an image of basically erotic content. Peters subsequently took holy orders, and was reportedly ashamed of his earlier exercises in titillation.

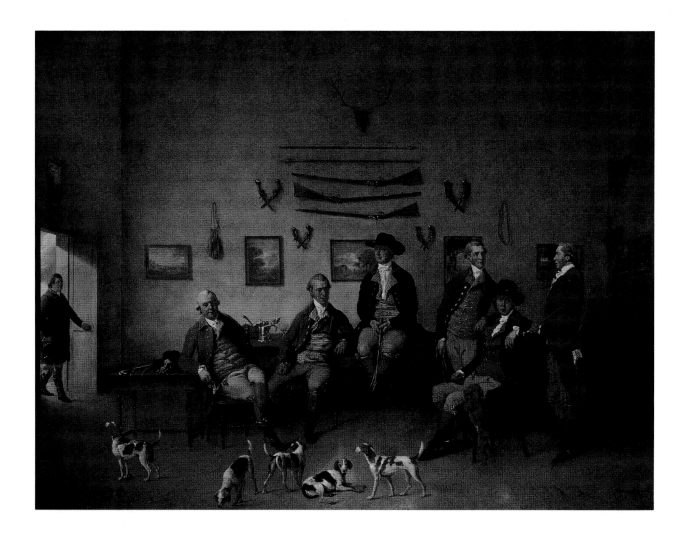

Philip Reinagle

1749–1833

**Members of
the Carrow
Abbey Hunt**
1780
Oil on canvas
114.9 x 152.4 cm

During the late eighteenth and nineteenth centuries many artists specialised in pictures depicting aspects of sporting life, reflecting one of the preoccupations of the wealthy gentlemen who were most prevalent as art patrons during the period. Sporting pictures generally showed a more relaxed side of the English gentleman, as they were intended to be appreciated in private between men, and so did not have to stress the formal public side of the sitters. Reinagle's painting depicts members of the Carrow Abbey Hunt of Norwich, using the conventions of the conversation piece. The figure seated on the table at the centre of the picture is John Morse, brewer, and later Mayor of Norwich, while the other figures can all be identified as stoutly professional men from the local area. The setting is a private lodge, itself hung with sporting art and guns. Hunting was beginning to be criticised for the cruelty it involved and for the excessive drinking and unruly behaviour of the sportsmen, and in this picture the artist has stressed the robust but sensible character of his sitters rather than their sporting achievements.

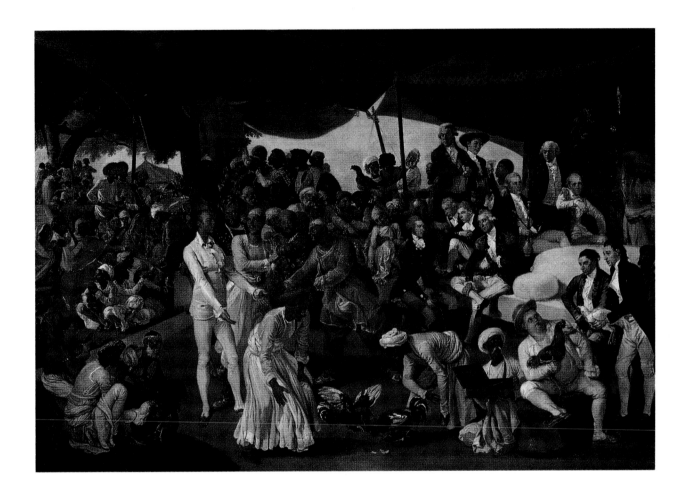

Johan Zoffany
1733–1810

**Colonel Mordaunt's
Cock Match**
c.1784–6
Oil on canvas
113.5 × 149.8 cm

This picture shows a cock match in India, at the court of Asaf-ud-daula, Nawab Wazir of Oudh. A fight is starting between the Nawab's cock and one of Colonel John Mordaunt's prizefighters imported from England. Mordaunt, an English mercenary who was commander of the Nawab's bodyguard, is shown standing to the left in white. Many of the other figures are identifiable, including the artist, who is seated at the top right. The lifestyle of Westerners in India was notorious for its immorality and corruption. Great fortunes were made there by businessmen and soldiers, who often came from outside

Britain's ruling elite, and the geographical distance from Britain meant that social rules were relaxed. Cockfighting itself was frowned upon at home. In Zoffany's painting, the unconventionality of life in India is given a sexual edge. The Nawab is shown as aroused, and within the general chaos of the scene there is a telling incident in the background, where a turbaned Hindu man assaults a Muslim boy. However, the picture was commissioned by Warren Hastings, the Governor-General of Bengal, and it seems unlikely that the picture is meant to be simply critical of colonial life.

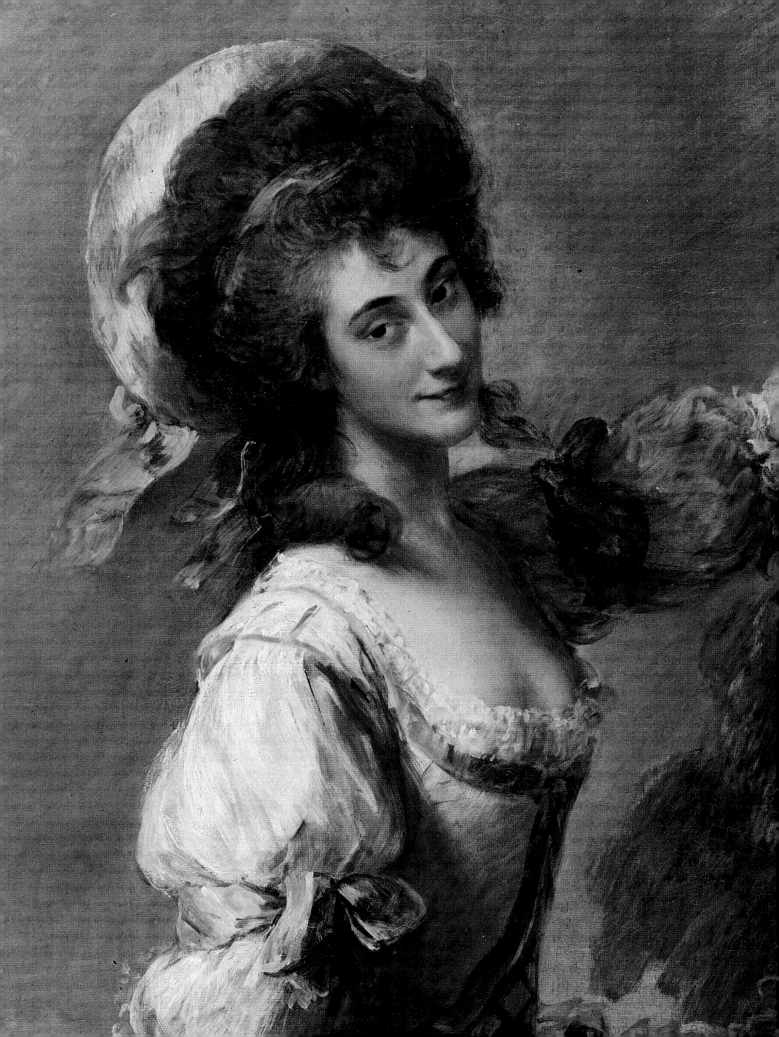

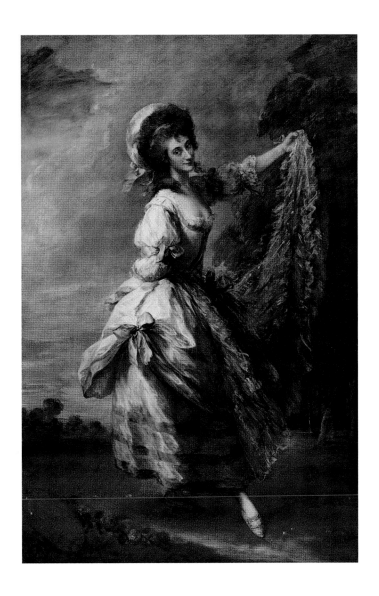

Thomas Gainsborough

1727–1788

Giovanna Baccelli

exh. 1782
Oil on canvas
226.7 × 148.6 cm

The Italian dancer Giovanna Zanerini, who took the stage name Baccelli, was one of the leading ballerinas of the late eighteenth century. She was also the long-term mistress of John Frederick Sackville, 3rd Duke of Dorset. The Duke commissioned this painting from Gainsborough for his country house, Knole, where rooms were kept permanently aside for her. Baccelli is shown in a costume from Simonet's *Les Amans Supris*, one of the ballets she performed in London during the 1780–1 season while at the height of her powers. When Gainsborough exhibited this portrait at the Royal Academy, his picture of the Duke was withdrawn from the exhibition;

presumably it was anticipated that an eagle-eyed gossip writer would draw a connection between the sitters. Although most upper-class gentlemen would expect to keep mistresses, it was thought improper to flaunt them quite so publicly, and actresses and dancers in particular were considered to be dubious characters. One art critic cruelly noted that in painting this picture Gainsborough had to 'lay on his colouring thickly', as his sitter was in life already painted with stage make-up, perhaps revealing discomfort with such a vivacious depiction of a woman whose status within polite society was much in question.

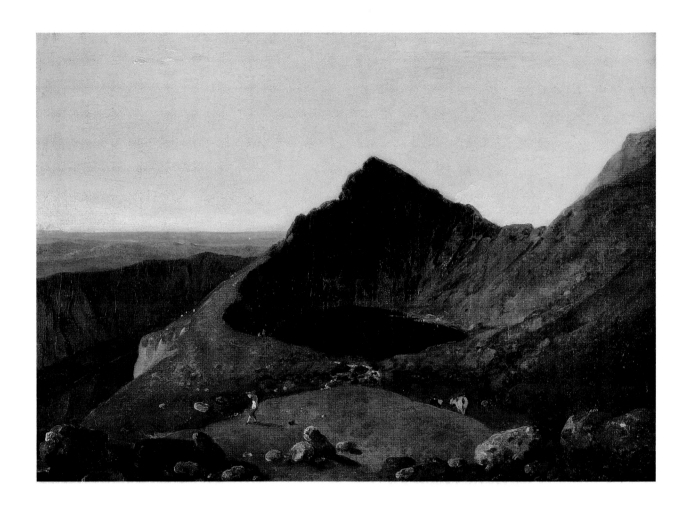

Richard Wilson
1713–1782

**Llyn-y-Cau,
Cader Idris**
c. 1765–7
Oil on canvas
51.1 x 73 cm

Wilson was the most successful painter of landscape working in England in the 1760s and 1770s, and based his style on the examples of the seventeenth-century artists Claude and Poussin, whose work was seen as expressing timeless, classical values. Once he had established his style in the 1760s, Wilson re-used the same pictorial devices throughout his career. This picture can be identified as showing the volcanic lake of Llyn-y-Cau, on the mountain of Cader Idris in North Wales. However, the artist has invented landscape features and heightened the precipice,

Craig-y-Cau, in order to create a simplified and balanced composition. In line with high-minded art theory of the time, this meant that the painting conforms to the orderly 'truth' underlying nature, rather than mere, deceptive appearances. It also meant that the image suited the contemplative and orderly vision of the natural world favoured by elite art patrons. The diminutive figures in the foreground underscore the scale of the natural features, but also, reassuringly, appear to be quite at home in this rugged landscape.

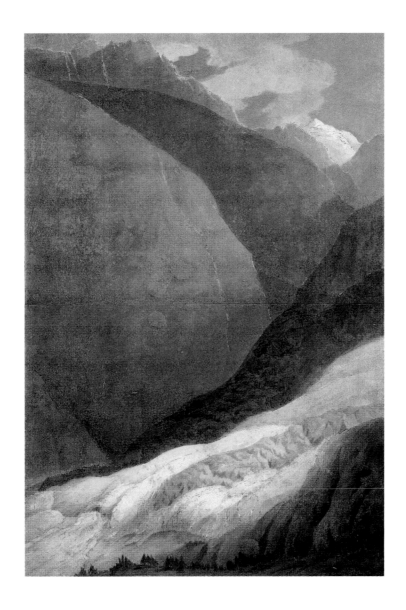

Francis Towne
1739–1816

**The Source of
the Arveyron**
1781
Pen and ink
and watercolour
on paper
31 x 21.2 cm

This watercolour depicts the source of the river Arveyron in the Alps, one of the most famous tourist sites in Switzerland in the late eighteenth century. The artist has dated it 'September 1781'. Towne usually provided quite detailed written comments on his drawings, stressing the precise time of the execution and highlighting his first-hand observation of the landscape. However, in a radical departure from the conventions of topographical painting, the scenery is only the starting point for a highly imaginative and almost abstract evocation of natural grandeur that defies the conventional rules of perspective. Thus the picture can be considered an exercise in the Sublime, the aesthetic appreciation of over-whelming grandeur and even fear that was becoming popular. Notably, Towne has excluded any human presence in the image, while artists depicting these sorts of views would conven-tionally include some small figures to give a sure sense of scale and indicate the equitable relation-ship between man and nature. Ideas about the Sublime emerged as conventional standards of beauty were coming into question, and as the appreciation of more personal and individual artistic visions was increasing.

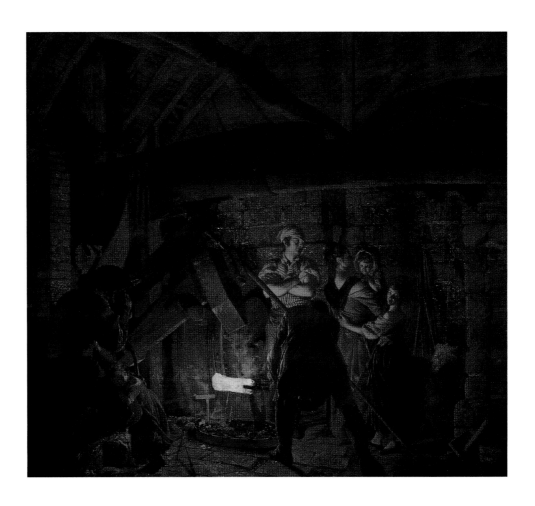

**Joseph Wright
of Derby**
1734–1797

An Iron Forge
1772
Oil on canvas
121.3 × 132 cm

Joseph Wright was a portrait- and subject-painter based in Derby, Liverpool and London. He is now best remembered for his scenes of contemporary industrial and scientific life. This picture shows a small iron forge at work, with what we must assume is the forge-master's extended family looking on. Although this painting is often taken as an illustration of the Industrial Revolution, the technology that Wright depicts was not especially advanced. Rather, the modernity of the painting lies in its heroic treatment of a theme from common life. The extraordinary light effects and dramatic composition endow this everyday scene of working men with almost religious grandeur, and by showing the various members of the family, Wright may be hinting at the noble theme of the 'ages of man'. According to the high-minded art theories promoted by the elite classes, such a prosaic scene from the life of ordinary working people did not deserve such a dignified treatment. Through the mass publication of prints after his works, and the public exhibition of his paintings, Wright reached out to new and less exclusive audiences for art.

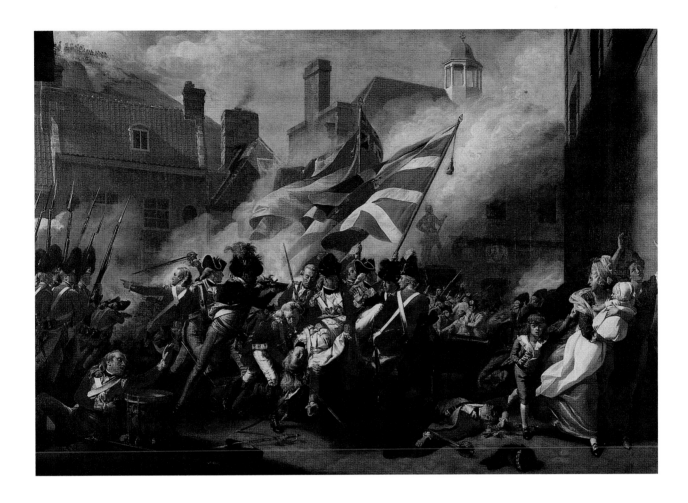

John Singleton Copley
1738–1815

The Death of Major Peirson, 6 January 1781
1783
Oil on canvas
251.5 × 365.8 cm

This large painting depicts a battle between French and English troops that took place on Jersey in 1781 during the conflict sparked off by the American Revolution. During the skirmish the young Major Peirson was killed, and his personal servant immediately revenged his death. Following the lead of his mentor and fellow American, Benjamin West, Copley became famous for painting dramatic scenes of contemporary events in an elevated pictorial style. Here the composition as a whole refers to a tradition of painting scenes from history or the Bible; the group around Peirson recalls depictions of Christ's descent from the Cross, while the women and children on the right derive from a painting by Raphael. In painting a contemporary news event, Copley was appealing to a wider audience than that familiar with more traditional subject matter. The painting was put on public show, not at the official exhibition of the Royal Academy, but at a privately rented venue where visitors were charged for entry. This was a novel sort of display and marked the emergence of art as a kind of urban spectacle or entertainment, rather than being the private pleasure of only the wealthiest.

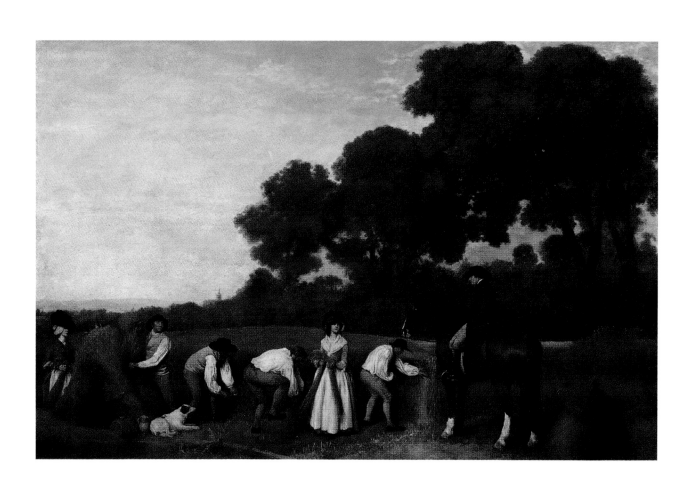

George Stubbs

1724–1806

Reapers

1785
Oil on wood
89.9 × 136.8 cm

The painting shows rural labourers harvesting wheat, and forms one of a pair with *Haymakers*. Although the painting is highly detailed and subtle in its treatment of the figures' postures and the landscape, giving the impression of directly observed nature, we know that Stubbs laboured over an extended period to get this effect. He made numerous drawings and studies for the picture, and had already finished a version of the subject in 1783. The picture presents a positive image of the rural world, where a small team of well-dressed workers labour happily, under the stern gaze of the farm manager seated on horseback. The rhythmic arrangement of the figures, each engaged in one of a sequence of actions, denies them a convincing sense of individuality, except for the young woman who is positioned to engage the viewer's attention. Although the poses seem to have been based on direct observation, the wheat as shown is actually too low to need harvesting, and a real harvest would involve a much larger workforce. Stubbs has contrived a highly artful fiction about the countryside, one that was particularly reassuring given the rise of industrial unrest in rural areas in the period.

George Stubbs, *Haymakers* 1785, oil on wood
89.5 × 135.3 cm

Thomas Jones

1742–1803

Naples: Buildings
on a Cliff Top
1782
Oil on paper
28.7 × 38.7 cm

Thomas Jones was a gentleman and amateur landscape painter trained by Richard Wilson. Like his master, Jones spent a prolonged period in Italy and his paintings are richly evocative of the light and atmosphere of the country, which was seen by Britain's elite as embodying the last vestiges of the esteemed ancient world. This picture shows a scene in Naples, an area often visited by British travellers. It probably represents a view out of the window of one of the lodging houses in which the artist stayed. Jones was among the first British painters to paint sketches directly in front of the landscape. At the same time, the picture provides a strong sense of formal structure and organisation. The composition is relatively flat and linear, and paint is applied in solid, constructional blocks of colour. This kind of experimentation would have been too radical for a full-scale oil painting intended to be shown in public, where certain standards of perspective and finish were expected to be upheld. Nonetheless, oil-sketching became an important practice for many artists in later decades, allowing for formal innovations that were impossible in works intended for public display.

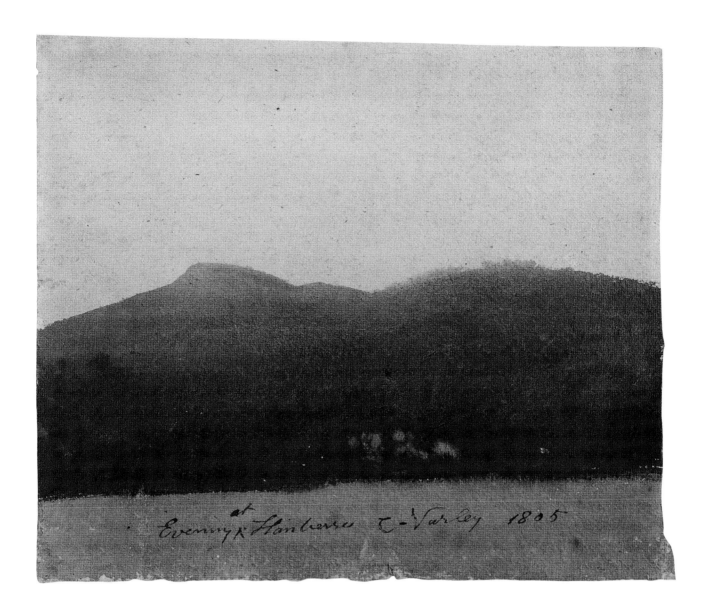

Evening at Llanberis C. Varley 1805

Cornelius Varley

1781–1873

Evening at Llanberis, North Wales

1805
Watercolour
on paper
20 × 23.8 cm

Cornelius Varley was the younger brother of the better-known watercolourist John Varley (1778–1842). In the 1790s, Cornelius attended the drawing school of Dr Thomas Monro, where the experimental use of watercolour and direct study of nature were encouraged. Varley had little success as an artist in his lifetime, and was as much occupied with making scientific instruments as he was with art. Like that of his contemporaries, Varley's vision of landscape combined a precisely naturalistic approach to recording the effects of light and atmosphere with a new emotional engagement with the landscape as the source of inspiration and a place for meditation. Although intensely personal in character, Varley's watercolour signals a larger change in artistic practice in early nineteenth-century Britain. Forcibly detached from European art and the Continent itself by the long wars with France (1793–1815), British artists increasingly became concerned with national subject matter. Furthermore, the emotional and formal freedoms displayed in the work of the most innovative landscape painters – here bordering on a kind of psychologically charged abstraction – were seen as embodying the political and personal freedoms that were meant to be a distinctly British privilege.

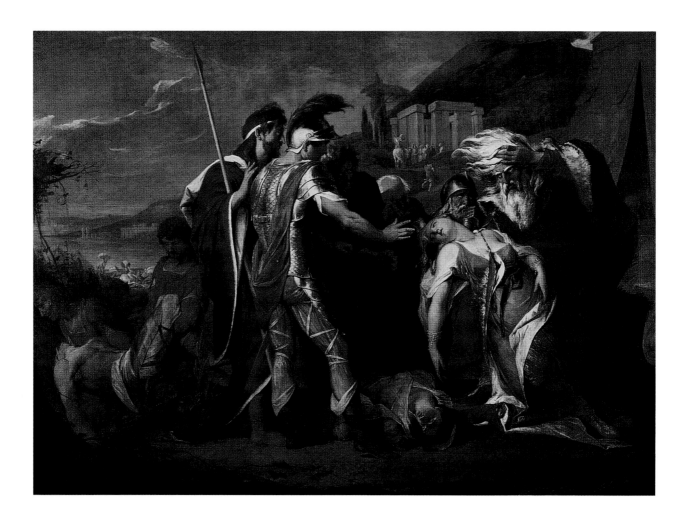

James Barry
1741–1806

**King Lear Weeping
Over the Dead
Body of Cordelia**
1786–8
Oil on canvas
269.2 × 367 cm

Barry was perhaps the most high-minded artist at work in London in the late eighteenth century, and stood fast by the tradition of 'grand manner' painting derived from Renaissance Italy. However, he had few opportunities to execute such works, given the lack of practical or financial support for such high ideals from private patrons or public bodies. This work was the result, instead, of an important commercial venture; the Shakespeare Gallery established by the entrepreneur John Boydell in London and first opened in 1789. Boydell commissioned a series of large-scale depictions of scenes from Shakespeare that he

exhibited at this specially designed gallery. Boydell was intending to promote the sale of prints reproducing the paintings. Barry was particularly well known as a painter of serious subjects, and executed this large-scale depiction of Shakespeare's Lear lamenting the death of his spurned daughter, Cordelia. The use of scenes from Shakespeare, rather than from ancient literature or the Bible, was meant to appeal to a more socially diverse audience, who may not have been educated in the classics, but would have known the Bard's plays from the London theatre and popular publications.

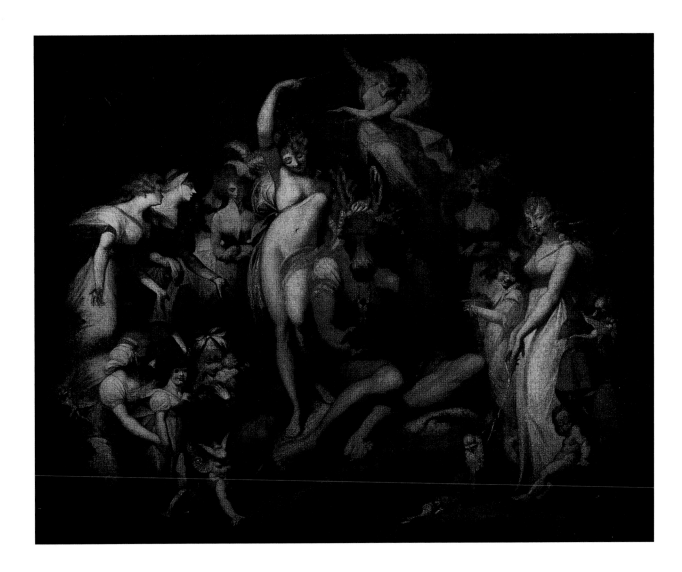

Henry Fuseli
1741–1825

Titania and Bottom
c. 1790
Oil on canvas
217.2 × 275.6 cm

This painting illustrates a scene from Shakespeare's *A Midsummer Night's Dream*. Titania, Queen of the Fairies has had a magic potion squeezed into her eyes while asleep, which will ensure that she will fall in love with the first creature she sees when she awakes. Comically, this is Bottom the weaver, who has the head of an ass. The picture was commissioned by Boydell for his Shakespeare Gallery. Fuseli, born Johann-Heinrich Füssli, was the son of a Swiss painter, yet was forced to follow a vocation as a priest. In 1762 he turned his back on his religious career and in 1764 came to England, working as a translator and illustrator. From the outset, he was an enthusiast for English literature and theatre, and among his earliest drawings are depictions of the London stage. Following a prolonged trip to Italy in the 1770s, Fuseli established himself as the leading painter of grand, theatrical scenes, often tackling bizarre and emotional subject matter. This work is typical of the artist in its combination of a deliberately, and rather pretentiously, darkened 'old masterly' look with fantastical subject matter calculated to appeal to a broad audience.

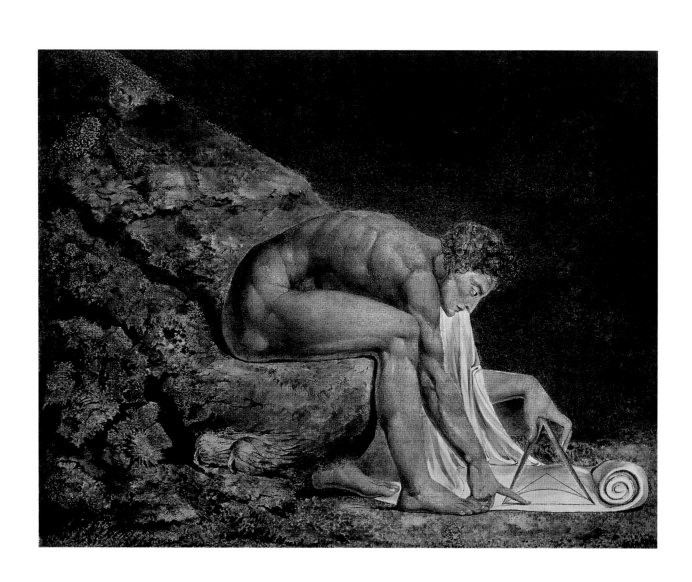

William Blake

1757–1827

Newton

1795 / c. 1805
Colour print
finished in ink
and watercolour
on paper
46 x 60 cm

William Blake began his career as a reproductive engraver and illustrator, and undertook a conventional training at the Royal Academy. However, motivated by his spiritual and political commitments, Blake moved away from traditional media into technically innovative printmaking and an elaborate symbolic language closely allied to his equally original poetry. This hand-coloured print comes from a series of twelve large prints conceived in 1795 and reworked in 1805. It presents Blake's highly personal vision of the figure of Sir Isaac Newton. Newton was considered at this time to be the founding father of modern science, and a canonical figure in the history of British philosophy. His unrelenting rationalism was taken as a model by the middle-class purveyors of intellectual Enlightenment. For the Nonconformist and artisan-class Blake, however, such materialism was anathema. He shows Newton at the bottom of a dark ocean, far from the light of true, spiritual knowledge, measuring the world scientifically with a compass. Blake thought that the mystical and intuitive should take priority over scientific reason, and had written: 'He who sees the Infinite in all things sees God. He who sees the Ratio sees himself only'.

Joseph Mallord William Turner

1775–1851

Crossing the Brook
exh. 1815
Oil on canvas
193 × 165.1 cm

This painting depicts the Tamar valley in Devon but, in a tradition of landscape painting going back in English art to Richard Wilson and George Lambert, and beyond to the seventeenth-century artists Claude and Poussin, Turner presents it as an idealised, Italianate scene. The use of balanced 'screens' of trees at left and right and the carefully controlled illusion of deep spatial regression derive from these earlier examples. Turner was one of the artists who took the art of landscape painting to new heights during the first decades of the nineteenth century. During the prolonged wars with France and with tremendous social and political upheaval at home, paintings of English landscape scenery like this were seen as ever more significant. Turner, like many of the artists and poets of his generation, was highly anxious about the changes taking place in the world around him, and often appealed to a sense of nostalgia and supposedly unchanging values through his work, here embodied by the traditional pictorial conventions he used. However, within the first few decades of the nineteenth century Turner and his contemporaries broke with these formulae in searching for more convincing and still more subtle ways of depicting the countryside.

John Constable
1776–1837

Flatford Mill
(*'Scene on a
Navigable River'*)
1816–17
Oil on canvas
101.6 × 127 cm

John Constable is now considered as one of the most important landscape painters of the early nineteenth century. The picture shows the scenery familiar to Constable from his child-hood: the canals and working fields of Suffolk. His family owned a watermill and dry dock about a mile from this site. Such scenes had great emotional appeal to Constable, who claimed 'They made me a painter'. His treatment of the native landscape was highly innovative in its naturalism, apparent simplicity, and in his use of studies taken directly from nature. But this painting also presents the landscape as heavily worked by man and stresses how economically productive this part of England was. The barge seen on the canal to the left was used to transport locally produced grain to the town of Mistley for shipment to London. The field on the right is tilled right up to the hedge, so that it will yield the greatest crop. The picture offers a reassuring view into the working landscape, where children and adults labour in a relaxed way.

William Blake

1757–1827

The Ghost of a Flea

c. 1819–20
Tempera heightened
with gold on
mahogany
21.4 × 16.2 cm

This, perhaps Blake's most famous painting, represents, according to an old label written by Blake's friend the artist John Varley, 'The Vision of the Spirit which inhabits the body of the Flea & which appeared to the Late Mr Blake … The Vision first appeared to him in my presence & afterwards till he had finished this picture'. It is one of a series of drawings and paintings of historical personages and fantastic characters produced by Blake between 1819 and 1825, supposedly based on visions experienced at Varley's house. In the years following Blake's death his reputation rose dramatically among younger artists, and stories about his eccentricity abounded. However, many of these were fanciful, particularly those regarding his visions. With the emergence of new ideas about 'genius', Blake's highly individual character as an artist took on a special significance. For younger artists, and for collectors keen to promote his work, the supposedly eccentric sources of Blake's inspiration demonstrated his authenticity as an artist and, equally, his alienation from mainstream culture. The unusual technique of tempera (glue-based paint) was referred to by Blake as 'fresco', and was meant to evoke the honest simplicity of medieval and Early Renaissance art.

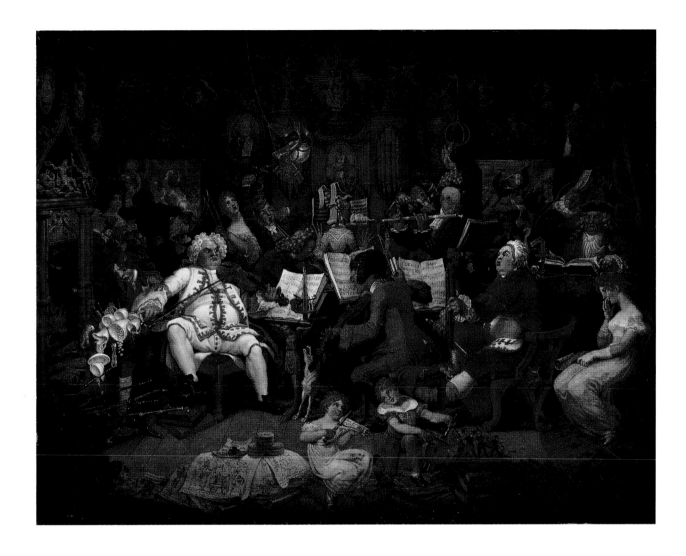

Edward Francis Burney

1760–1848

Amateurs of Tye-Wig Music ('Musicians of the Old School')

c.1820

Oil on canvas

68.6 × 83.9 cm

This comic painting is an attack on conservative taste in music, at a time when there was great debate between the Ancients who preferred the orderly, rational music of Handel and Mozart, and the Moderns who preferred the emotive music of Beethoven. It shows amateur musicians performing what was then considered old-fashioned music – perhaps by Handel, a bust of whom overlooks the scene. They have discarded scores by Beethoven and others, which can be seen threatened by the flames in the fireplace. Burney was trained as a fine artist at the Royal Academy Schools, but like many of his generation could not support himself by 'high art' and was generally preoccupied with comic art and illustration. He was the nephew of the famous musicologist Dr Charles Burney, and so would have been familiar with contemporary arguments about 'modern' taste in music. Burney produced a series of highly finished and elaborate water-colours on the theme of music, but this is the only finished oil painting on the subject by him. Comic scenes like this were popular in the nineteenth century, and often made light of what were at the time very serious issues regarding the changing character of British culture and society.

John Berney Crome
1794–1842

Yarmouth Harbour – Evening
c. 1816–21
Oil on canvas
40.6 × 66 cm

Like his father, the painter John Crome, John Berney Crome is considered a member of the so-called Norwich School of painters. The term is used to denote what was actually a very diverse group of artists, especially landscape painters, working in Norfolk in the nineteenth century. They represented a highly romanticised view of the English landscape, its 'picturesque' working life and distinctive light and atmosphere. Like other coastal areas, Great Yarmouth was thought of as offering a haven from the increasingly un-

healthy and crowded conditions of metropolitan centres, and was popular as a tourist resort. Crome's picture depicts the tranquil conditions that were imagined as typical in Norfolk, contributing to the developing nationalist mythology surrounding key sites in England's landscape. Although the painter's work is particularly associated with Norwich and the surrounding region, Crome actually travelled extensively and painted scenes of Holland and France as well, and had a truly national reputation as an artist.

John Constable

1776–1837

Sketch for
Hadleigh Castle
c. 1828–9
Oil on canvas
122.6 × 167.3 cm

This is the full-scale painted sketch for one of Constable's 'six-footers' – the ambitious paintings he showed at the Royal Academy in London from 1819 onwards. During this period he was trying to show that landscape painting could be an elevated artistic genre in its own right. Constable was a great admirer of Sir Joshua Reynolds, and evidently wanted his landscape paintings to convey the intellectual and poetic qualities more conventionally associated with subjects taken from the Bible or high literature. Here this ambition is signalled in the scale of the painting and the use of an historic ruin with all its associations with the ancient past. The central role of the castle and the storminess of the painting suggests an emotional involvement with the landscape that was quite new in art. This picture was executed during 1828–9; the fact that Constable's wife, Maria, died at the end of 1828 has affected how people have looked at this painting. Some see the turbulence of the painting as expressive of Constable's emotions at this period. Certainly, the rough surfaces of his paintings were said by contemporaries to represent his forthright emotional honesty, thought at the time to be a characteristically British quality.

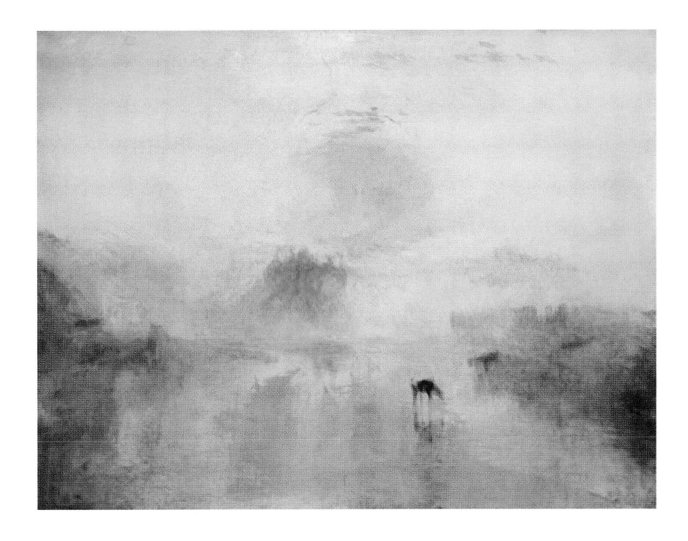

Joseph Mallord William Turner

1775–1851

Norham Castle, Sunrise

c.1845
Oil on canvas
90.8 × 121.9 cm

This is one of a series of depictions of Norham Castle on the river Tweed, on the borders of England and Scotland, that Turner produced from his first visit there in 1797 through to the last years of his life. It is not a finished painting, and may have been either a sketch for an unexecuted work or the 'lay-in' of the fundamental compositional structure that would have been worked up on the canvas in more detail. Despite the sketchiness of this painting, the basic skeleton of a traditional Classical landscape is apparent in the careful regression of space and the balancing of landscape forms. Turner would never have exhibited a painting in this state, and it was only at the turn of the twentieth century that such works began to be fully appreciated. At that time, his extraordinarily free treatment of light, colour and atmosphere was seen as pre-empting the artistic innovations of the French Impressionists, allowing critics to claim the existence of a distinctively British tradition of painting as modern and radical as anything on the Continent.

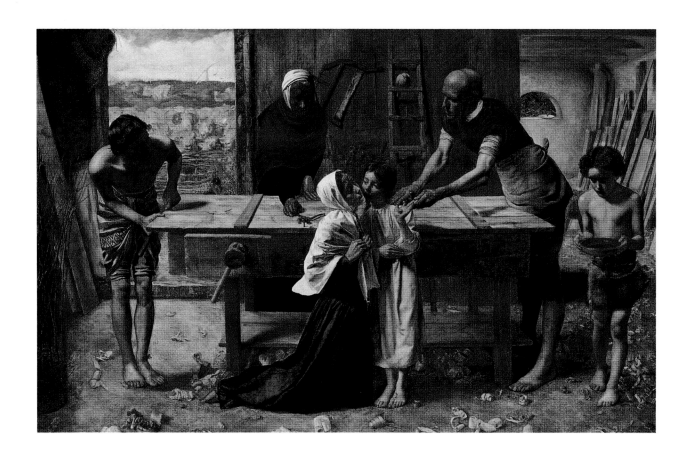

John Everett Millais

1829–1896

Christic in the House of His Parents ('The Carpenter's Shop')

1849–50
Oil on canvas
86.4 × 139.7 cm

Millais was a founding member of the Pre-Raphaelite Brotherhood, a clique of young artists formed in 1849 with the express purpose of re-forming modern art by emulating the laborious naturalism of early Italian painting. This picture caused a huge controversy when it was exhibited at the Royal Academy in London in 1850. It shows Christ as a child, being comforted by his mother after injuring his hand in his family's carpentry shop. Instead of painting in an elevated, abstracted style, Millais based every element on direct observation. Even the sheep's faces were painted from heads collected from his local butcher. Some critics thought that the dirt and disarray of the scene associated Christ with the lower classes, an idea repugnant to high-minded Anglicans. In his harsh review of the picture, Charles Dickens highlighted the dirty feet of the figures and wrote 'Their very toes have walked out of Saint Giles's' (St Giles was an area of London well known for its poor immigrant population, particularly its Irish Catholics). Despite Millais's exacting naturalism, the picture is also heavy with symbolism. The bloodied hand of Christ refers to his crucifixion as an adult, the dove perched on the ladder represents the Holy Spirit, and even the sheep may represent a congregation in a church, looking on to the altar-like carpenter's worktable.

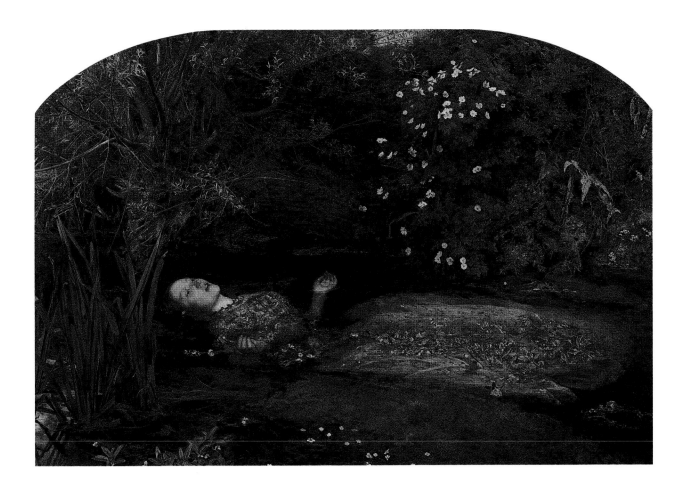

John Everett Millais

1829–1896

Ophelia

1851–2
Oil on canvas
76.2 × 111.8 cm

Shakespeare's Ophelia, driven insane by the murder of her father by her lover Hamlet, is portrayed singing in her madness as she drowns. The model for Ophelia was Elizabeth Siddal, a young working-class woman who was a favourite with the men of the Pre-Raphaelite circle and who later married the painter and poet Dante Gabriel Rossetti. The idea of 'saving' a woman from an impoverished lifestyle had great appeal for these artists, but was accompanied by an abusive attitude more typical of Victorian men. Elizabeth was made to sit in a bath for days so that Millais could base his drowning figure on observation. She caught a severe cold and her father insisted that the young painter pay the doctor's bills or he would sue. As in many Pre-Raphaelite works, the floral elements are introduced for their symbolic associations: the poppy, for instance, is a symbol of death.

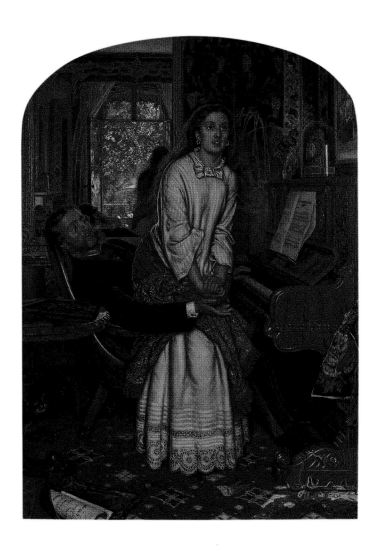

William Holman Hunt
1827–1910

The Awakening Conscience
1853
Oil on canvas
76.2 x 55.9 cm

Hunt shows the mistress of a well-to-do gentle-man arising from his lap in a moment of moral revelation, precipitated by the innocent theme of the music he is playing. The setting is a house in St John's Wood in London, an area favoured by wealthy men for illicit sexual encounters. Themes of sexual corruption and reform were common in the work of Victorian artists, registering the concerns felt about changing standards of morality. Here, Hunt's vivid Pre-Raphaelite technique is especially evocative, as the interior is crammed with the latest decorative wares and fripperies whose sparkling newness signal the vulgar fashionability of the couple and the fact that as the house is not a legitimate, domestically settled space, its contents are not subject to everyday wear and tear. Every detail has a further symbolic significance, such as the cat attacking the bird under the chair to the left, which alludes to the cruel exploitation of the woman by the man. The famous art critic John Ruskin thought very highly of the picture, and remarked on the 'fatal newness' of the furniture and decorative objects in the scene: 'there is not a single object in all that room ... but it becomes tragical if rightly read'.

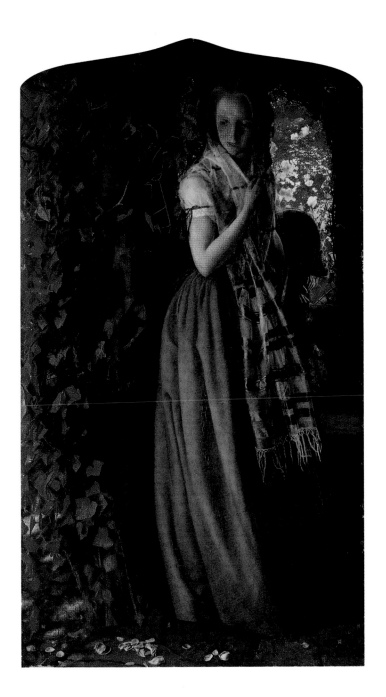

Arthur Hughes
1832–1915

April Love
1855–6
Oil on canvas
88.9 x 49.5 cm

When Hughes exhibited this picture at the Royal
Academy in 1856, he included a quote from
Alfred, Lord Tennyson's poem 'The Miller's
Daughter' in the catalogue entry. The poem deals
with the theme of the fragility of young love.
However, the subject matter of Hughes's picture
remains vague; while preparing the work, he
referred to it by several titles, including 'The
Lovers' Quarrel', and 'Hide and Seek'. The model
for the young girl was originally to be a hired
country girl, but she grew tired of modelling.
Instead, Hughes probably used his new wife,
Tryphena. Like other artists associated with the
Pre-Raphaelite movement, Hughes included
plants and flowers for their traditional associ-
ations. Here, the ivy symbolises everlasting life
and the roses, love. The scattered petals may
indicate that a love affair is ending. Such a
sentimental theme, involving the depiction of
a vulnerable and beautiful young woman, is
representative of much popular Victorian art,
and served to reinforce dominant ideas about
the emotional instability of the female sex.

Ford Madox Brown

1821–1893

The Hayfield

1855–6
Oil on mahogany
24.1 x 33.3 cm

During the 1850s Brown produced a series of small landscapes, which he hoped to be able to produce and sell quickly. However, his dedication to meticulous, Pre-Raphaelite painting techniques prevented him from working at speed. The artist painted most of *The Hayfield* directly from nature in the fields at Hendon, just north of London, finishing the foreground details in his studio. In contrast to earlier painters of the working landscape, Brown was above all concerned with atmospheric effects, rather than presenting a reassuring image of rural productivity. The scene shown by Brown is in fact quite unproductive;

in his notes on the picture Brown explained that it showed the stacking of a second crop of hay, 'much delayed by rain' which had created unusual colour effects. The rain may have heightened the colour of the grass, but it would also have spoiled the crop. Brown's romanticised view of the working landscape was typical of many idealistic thinkers in the mid-nineteenth century, who argued that a renewed appreciation of nature and (largely mythical) rural traditions could offer redemption from the corruption of modern, industrial life.

**William
Powell Frith**

1819–1909

The Derby Day

1856–8
Oil on canvas
101.6 × 223.5 cm

This picture shows Epsom Downs on Derby Day, the major annual race meeting that attracted huge crowds from nearby London. Frith was famous for such crowd scenes and was admired for his ability to convey a convincing sense of the variety of social types found among the growing urban population. This picture can be viewed as an elaborate exercise in physiognomy, the pseudo-science of assessing character and worth according to physical appearance. Frith's painting was part of a whole industry of image-making providing entertaining stereotypes for the public. These gave fixed visual form to the increasingly uncertain distinctions between

rich and poor, the criminal and the law-abiding, the virtuous and the corrupt. The clarity of his painting style (partly based on photographs) and the density of narrative detail served to present the picture as an observation of social 'fact' which demanded – as the picture's first owner Jacob Bell wrote – 'a close inspection to read, mark, learn and inwardly digest it'. For contemporaries, many of the figures would have been instantly recognisable as types – such as the rich man's mistress in the carriage to the right, the prostitute in brown riding clothes on the far left and the naive rural couple standing beyond her.

Richard Dadd
1817–1886

**The Fairy Feller's
Master-Stroke**
1855–64
Oil on canvas
54 x 39.4 cm

The starting-point for this picture was Shakespeare's *Midsummer Night's Dream*, but the figures of Titania and Oberon are virtually hidden towards the top of the canvas among the vast cast of characters invented by Dadd himself. In a rambling poem written a year after he stopped working on this painting, Dadd gave details about the figures that appear in it. At the centre of the canvas a fairy woodsman is preparing to strike a hazelnut. The crowded figures around him wait to see if he will successfully split the nut with a single stroke. They include the Patriarch, at the centre of the canvas, identifiable from his Papal crown,

a sinister-looking politician in a pink cloak just below him, and at the top of the picture a group of figures representing the different characters in the children's game 'soldier, sailor, tinker, ploughboy, apothecary, thief'. The intense and fantastical nature of this work derives from the examples of Blake and Fuseli, and was exaggerated by Dadd's mental instability. Dadd was trained conventionally as an artist, but he was imprisoned for life in 1843 after murdering his father. His warders allowed him to continue painting, and this work was executed for an official at Bethlem Hospital.

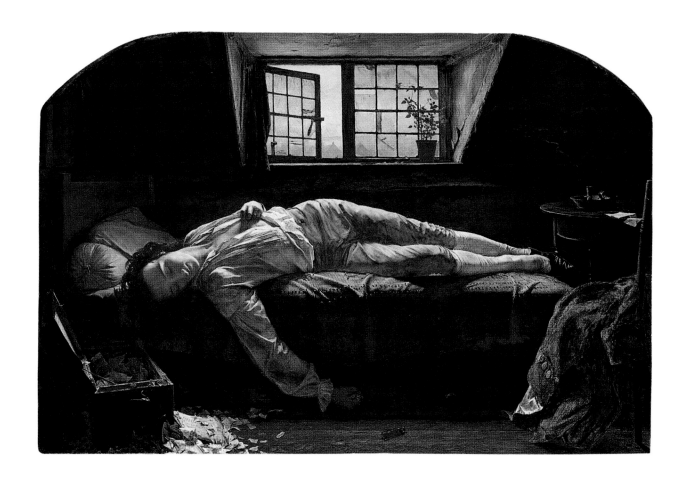

Henry Wallis
1830–1916

Chatterton
1856
Oil on canvas
62.2 × 93.3 cm

Thomas Chatterton (1752–1770) famously wrote forgeries of medieval poems. He was remembered for his melancholy life and suicide, which for artists of the nineteenth century represented the epitome of Romantic creative suffering. Wallis's picture shows the poet dying on his bed, in a stereotypically derelict poet's garret, his manuscripts strewn by his side. The figure's posture, dishevelled clothing and beautiful features hint at an almost erotic atmosphere, and the viewer is certainly invited to look long and close at the picture. As Ruskin directed when the picture was exhibited: 'Examine it well, inch by inch'. The Victorians made intimate, if often unconscious, connections between eroticism, death and poetic inspiration, and the cult that surrounded the teenage poet reveals much about their attitudes. The model used by Wallis for the figure of Chatterton was a friend, the struggling writer George Meredith, reinforcing the connection between the tragic poet and modern artists.

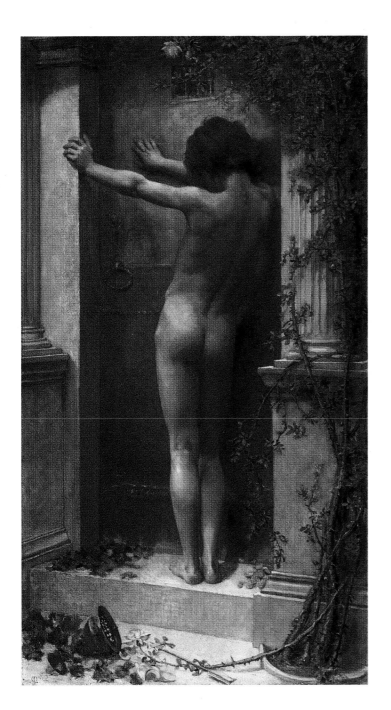

Anna Lea Merritt

1844–1930

Love Locked Out

1889
Oil on canvas
115.6 x 64.1 cm

Anna Lea was an American painter trained in Europe, who settled in London after marrying the English art critic and painter Henry Merritt in 1877. He died only three months after their marriage, and although they had a troubled relationship, Anna Lea Merritt commemorated his death by writing his memoirs, published in 1879, and designing a joint gravestone. The gravestone was never made, but the design formed the basis of this painting, which shows a naked child representing Love or Cupid 'waiting', as Anna Lea Merritt wrote, 'for the door of death to open and the reunion of the lonely pair'. The setting suggests an ancient building, and the form of the naked figure refers to Classical sculpture, giving the scene an otherworldly quality. Despite its sentimental intention, the nakedness of the androgynous figure of Cupid also locates the painting as part of a strain of covertly erotic imagery produced in the Victorian period. Although the Victorian middle classes remain famous for their prudery, the depiction of innocent children in suggestive poses was quite common.

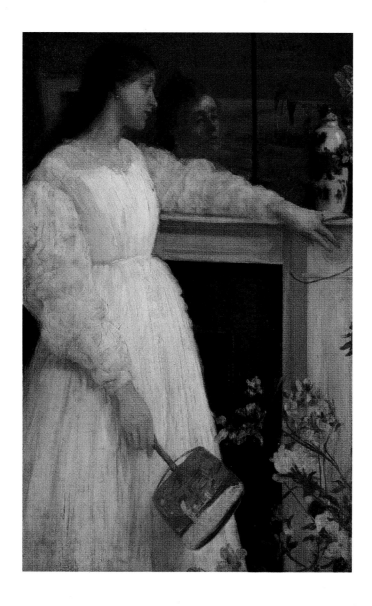

James
Abbott McNeill
Whistler
1834–1903

The Little White
Girl: Symphony
in White, No.2
1864
Oil on canvas
76.5 x 51.1 cm

During the 1860s Western artists became increasingly interested in the art and design of Japan. After centuries of resistance to the outside world, the first trade links between Western Europe and Japan were being forged, and traditional Japanese art became available. The International Exhibition held in Paris in 1861 brought Far Eastern arts and crafts to the fore. This painting by the American-born artist Whistler emulates the flatness and abstraction so admired in Far Eastern art. The picture is known to show the artist's Irish mistress, Jo Hiffernan, posed before a mirror. It was first exhibited as

The Little White Girl, and the anonymity of the figure, the uncertain significance of her expression, and the device of the mirror, served to suggest a variety of meanings to contemporaries. The writer Algernon Swinburne was inspired to compose a poem, which did little to unravel the possible meanings of the work. Whistler's mysterious, but highly fashionable images, appealed to wealthy patrons looking for art that appeared distinctly modern and rarefied, and that defied conventional artistic standards of perspective, finish or narrative.

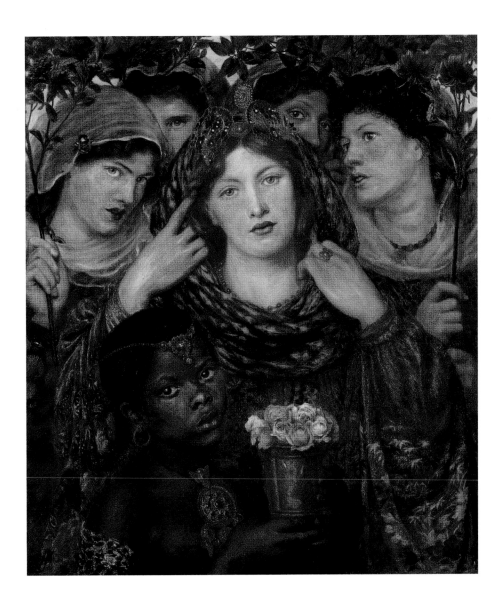

Dante Gabriel Rossetti

1828–1882

The Beloved ('The Bride')
1865–6
Oil on canvas
82.5 x 76.2 cm

Rossetti was a member of the Pre-Raphaelite Brotherhood, but from the 1860s he departed from their original moral intentions and produced a series of suggestive and luxuriant works focused on the features of an idealised woman. This picture started as a portrait of Beatrice, the woman idolised by the Italian poet Dante. Rossetti subsequently adapted the picture as a treatment of the Song of Solomon from the Old Testament, particularly the lines in praise of physical beauty (2:16) which are inscribed on the frame. Despite the undeniable beauty and richness of Rossetti's painting, this picture also gives frank visual form to predominant contemporary ideas about race. The central, and purportedly most beautiful woman in this image is shown with the whitest skin. The black child is relegated to the bottom of the picture, serving to underscore the maturity and paleness of the white woman. Furthermore, the rich materials on display in this picture are recognisably imports from around the world, highlighting the fashion for 'exotic' textiles made possible by Britain's global commercial dominance.

Edward Coley
Burne-Jones
1833–1898

The Golden Stairs
1880
Oil on canvas
269.2 × 116.8 cm

This painting was first exhibited in the exclusive
setting of the commercially run Grosvenor
Gallery in London in 1880. The gallery was
the showroom for the most fashionable and
advanced art of the time, and the novelty of
Burne-Jones's painting was the source of much
discussion when it was first shown. Paintings
on this ambitious scale traditionally used clearly
identifiable literary or historic sources, but there
is no such origin known for *The Golden Stairs*. The
connotations of the work are thus unclear, and
Burne-Jones would never identify its meanings.
Rather, in common with advanced artists and
aestheticians in Britain and Europe, he was con-
cerned with creating an emotional effect through
the formal rhythm of the image and arcane
symbolism. Revealingly, one of the titles con-
templated for this work was 'Music on the Stairs'.

Dante Gabriel Rossetti

1828–1882

Proserpine

1874
Oil on canvas
125.1 x 61 cm

During the 1870s Rossetti's highly mannered
treatment of the female face became still more
extreme, and he developed an almost fetishistic
treatment of his models' impossibly lush features
(particularly their fleshy mouths). Plagued by
ill health, he spent long periods at the home
of William Morris, and had a long-term and
intimate relationship with his host's wife, Jane.
It was Jane Morris who modelled for this
painting. The subject is the mythical figure
Prosperine, who was cursed to be the Empress
of Hades (hell). The pomegranate she holds
represents captivity and the ivy branch, memory.
The picture may have been loaded with personal
significance for Rossetti, given his relationship
with the model, but his decadent vision of
women as dangerous temptresses was shared
with many of his contemporaries.

John William Waterhouse

1849–1917

The Lady of Shalott
1888
Oil on canvas
153 × 200 cm

The subject of this painting is taken from Alfred, Lord Tennyson's 'The Lady of Shalott' (1832). Tennyson's poem was used as the basis of many paintings in the late nineteenth century. Its themes of sexual repression and punishment attracted Victorian artists seeking poetic subject matter with contemporary relevance. Based in the time of King Arthur, the poem tells the story of a woman cursed to live in isolation on the river island of Shalott. She is allowed to see the outside world only in a mirror, but on glimpsing the reflection of the handsome knight Lancelot, she cannot resist looking at him directly. In punishment, she is sent drifting down the river towards Camelot, singing, but dies before reaching her destination. This is the scene depicted by Waterhouse. Tennyson was a severe moralist and his poem reveals his association of sexual temptation with death, which remained current in the later nineteenth century. The prevalence of venereal disease and the emergence of the women's liberation movement led to a heightened sense of anxiety about female sexuality, and in an oblique way this picture shares that anxiety by showing a woman being punished for her sexual feelings.

Frederic,
Lord Leighton
1830–1896

The Sluggard
1885
Bronze
191.1 x 90.2 x 59.7 cm

Leighton was the most successful artist of the later nineteenth century, and having trained on the Continent rose rapidly through the ranks of the Royal Academy, becoming President in 1878. He was primarily a painter, and his work was noted for its extraordinary technique and evocation of an ideal, if sometimes decadent, ancient world. He also produced sculptures, though only on two occasions did he produce finished life-sized works. *The Sluggard* combines a precisely naturalistic treatment of anatomy with a sense of superhuman perfection derived from Classical models. The absence of narrative content and the literal treatment of the nude were novel features of the period. Despite Leighton's success within the art establishment, his foreign training, evident debt to the example of modern French sculpture and uninhibited treatment of the male nude drew criticism from conservative critics who were worried about foreign influences on British art (and, in turn, the increasingly precarious position of Britain as a world power). He, and his work, were attacked as typifying effeminate, Francophile 'dandyism'. The very smoothness and technical polish of his work signalled to his critics a fussiness and perfectionism perceived as 'unmanly'.

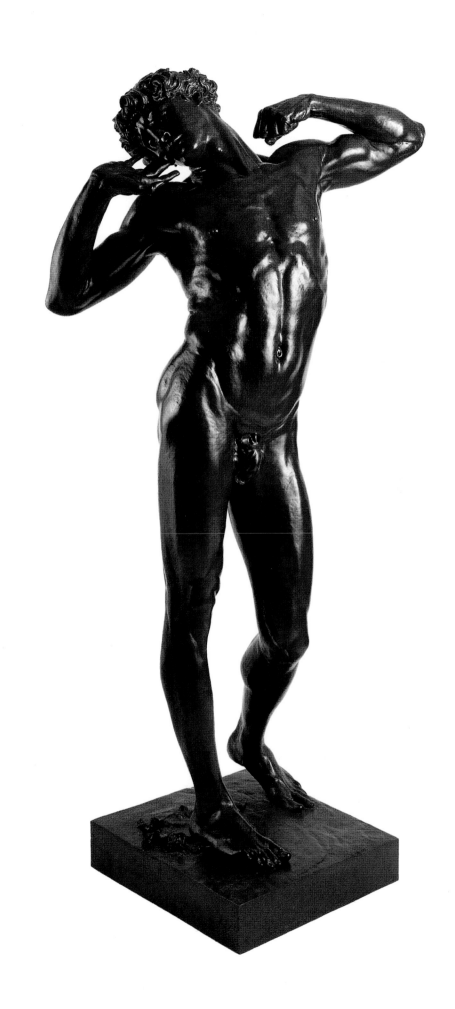

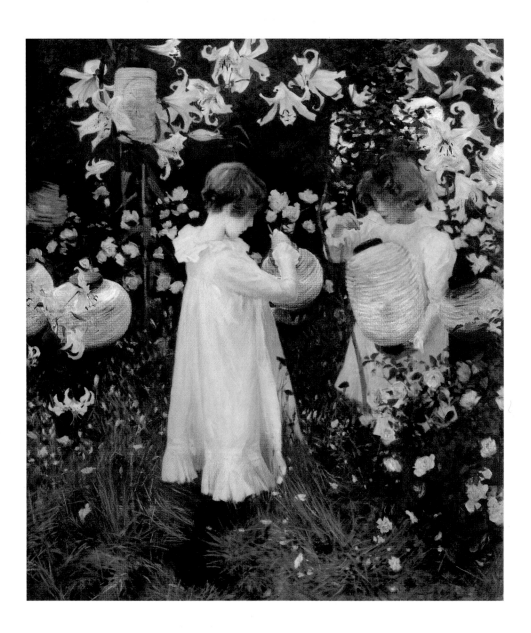

**John Singer
Sargent**
1856–1925

**Carnation,
Lily, Lily, Rose**
1885–6
Oil on canvas
174 × 153.7 cm

This picture was begun when Sargent was staying with the painter F.D. Millet at his house at Broadway, in the Cotswold Hills, an area then popular with artists and writers, including a number of Americans, like Sargent. It shows the daughters of the illustrator Frederick Barnard, who also lived in Broadway, lighting Japanese lanterns at dusk. Sargent worked on the painting out of doors for a period of more than two months in the autumn of 1885, setting up his easel in the garden each evening and attracting a growing audience of his peers on every occasion.

The artist continued to work on the picture until October 1886. The concern with the accurate depiction of fleeting light effects stemmed from the example of the French Impressionists, but such a theatrical performance was especially typical of Sargent, whose virtuoso technique and charming subject matter captured the imagination of the wealthy and fashionable of his time. This work combines the painterly experimentation typical of Impressionism with the 'exotic' elements that were also so modish within advanced circles.

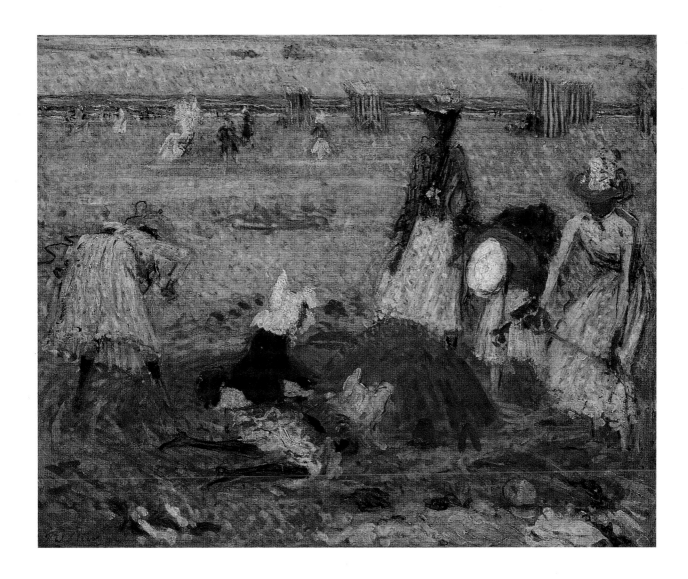

**Philip Wilson
Steer**
1860–1942

Boulogne Sands
1888–91
Oil on canvas
61 × 76.5 cm

Philip Wilson Steer was the son of a painter and had a quite conventional art training in England. However, in 1882 he travelled to Paris to further his study of art, and came into contact with the Impressionists. In works such as this, showing a group of girls on the beach of the French holiday resort Boulogne, he followed their example in exploring the potential for broken paint surfaces and extreme colour contrasts to evoke fleeting atmospheric effects. Steer's painting of the 1880s represents a rare moment of stylistic innovation in late nineteenth-century British art; in general patrons leaned toward more conservative styles, or the allusive qualities of Symbolist painting. Later, Steer's style became more traditional, and he produced landscapes deliberately evocative of Gainsborough and Constable, then being promoted as exemplars of a distinctly 'British' way of painting.

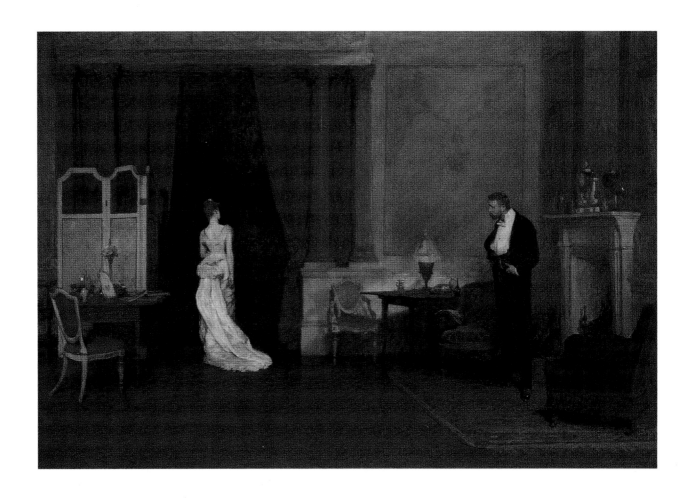

William Quiller Orchardson

1832–1910

The First Cloud
1887
Oil on canvas
83.2 × 121.3 cm

During the second half of the nineteenth century, a number of artists exhibited paintings of contemporary life that hinted at some scandal, domestic tension or personal tragedy. In this case, a fashionable young couple is shown in their parlour in the aftermath of an argument. When exhibited at the Royal Academy in 1887, the catalogue entry included lines from Tennyson: 'It is the little rift within the lute / That by and by will make the music mute', suggesting that this first dispute would lead to more serious marital problems. The empty space between the figures, muted colour range and the elusive suggestion of a larger narrative create a sense of psychological tension. The last decades of the century saw rapid change in the domestic life of many people, with new divorce laws, a greater sense of psychological independence among wealthy women, and continuing anxieties about the instability and transformation of the modern family. Orchardson was the most adept British painter to play on these concerns.

Walter Richard Sickert

1860–1942

Ennui

c. 1914

Oil on canvas

152.4 × 112.4 cm

This is one of a series of pictures by Sickert depicting couples in domestic settings. The French title means 'boredom', and the curious composition, awkward poses of the figures and oppressive colour scheme give a strong feeling of discomfort. Sickert used his usual models: Hubby, his odd-jobman and Marie Hayes, his charlady. Although his use of colour and his unconventional compositional compression show knowledge of the latest innovations of Impressionism and Post-Impressionism, the artist remained committed to the anecdotal subject matter of his Victorian predecessors.

Virginia Woolf wrote an essay on Sickert focusing on this image after she saw a version of the painting in an exhibition in 1933. She imagined the scene depicted the backroom of a pub, the landlord 'looking out of his shrewd little pig's eyes at the intolerable wastes of desolation in front of him', while his wife 'lounges' and is unable to stir herself to serve an impatient drinker waiting at the bar. Although there is no evidence that such an interpretation is 'right', Woolf astutely identified the temptation to provide stories for Sickert's pictures, even when only partly supported by the images themselves.

André Derain

1880–1954

The Pool of London

1906
Oil on canvas
65.7 x 99.1 cm

This painting, showing the view towards Tower Bridge from London Bridge, was painted on the spot in 1906, when the French painter Derain visited London. He worked closely with Henri Matisse, and was a leading proponent of the so-called Fauvist style, typified by the denial of illusionistic space and a confrontational use of anti-naturalistic colours. Derain's choice of the Thames as subject matter recalls a tradition of imagery, most recently the London paintings of Claude Monet, which had been exhibited in Paris in 1904. The foregrounding of the steamship, and general bustle of the scene, are indicators of London's status as a modern and commercial European capital at this time. Derain's picture was an attempt to update Monet's images, stressing the modernity of the capital and his own painting style. Like other Fauves, Derain exploited a 'primitive' artistic technique, with its associations of primal virility, to celebrate the vitality of modern life in Western Europe.

Vanessa Bell

1879–1961

The Tub

1917

Oil and gouache on
canvas

180.3 × 166.4 cm

Vanessa Bell was part of the close-knit, almost incestuous, community of well-off artists, critics and writers known as the Bloomsbury set. The artists associated with Bloomsbury pursued an art of decorative aesthetic purity, largely detached from social reality. Bell's painting style was modelled on the work of the French artist Henri Matisse, which the Bloomsbury art critic Roger Fry and others considered exemplary of this aesthetic ideal. This work was executed after Bell moved with the painter Duncan Grant and the writer David Garnett to Charleston Farm-house on the South Downs in Sussex. It was intended to decorate the garden room, but was never installed. The confrontational use of colour, 'primitive' treatment of the figure's features, and disregard for traditional perspective all register a fashionably avant-garde approach.

David Bomberg
1890–1957

In the Hold
c. 1913–14
Oil on canvas
196.2 × 231.1 cm

This is one of a series of pictures by Bomberg taking as their starting point aspects of life in the East End of London, which the artist knew at first hand having grown up in the Jewish community in Whitechapel. *In the Hold* represents a scene of dockers and the cargo they carry within the hold of a ship. Although the picture is initially dazzling, concentrated examination will reveal fragments of their forms just visible through the disruptive abstract grid and colour scheme; the light blue shapes in the central left area of the canvas connect together into the form of a dockworker wearing a hat, with out-stretched arms, while a ladder crosses the image on the right-hand side of the picture. However, these impressions are fleeting and ambiguous. Like a number of his contemporaries, Bomberg proclaimed his search for a new kind of visual language that would embody the speed and violence of modern urban life and herald the emergence of a new cultural order. Bomberg was identified as a leading avant-garde artist in England, and received the then indiscriminately applied epithet, 'futurist'.

Wyndham Lewis
1882–1957

Workshop
c. 1914–15
Oil on canvas
76.5 × 61 cm

The painter and writer Wyndham Lewis was at the forefront of the English artistic avant-garde, and was particularly associated with the Vorticist movement. The group included the poet Ezra Pound, and through the journal *Blast*, they heralded the arrival of a brutal new aesthetic based on the physical and psychological conditions they claimed characterised the modern age. *Workshop* exemplifies those values: the title may refer to Britain's status as the 'workshop of the world', celebrating Britain's imperial and commercial supremacy. The forms of the picture refer in an oblique way to the angular forms of the mechanic's workplace; their rhythm more obviously suggests the repetitive and violent activities of modern industry. The dry draughtsmanship and inexpressive application of paint may even refer to engineering drawings, rather than artistic traditions. Like many intellectuals in Europe at this time, Lewis wanted to celebrate the inhuman brutality of the modern world, and his personal outlook mixed authoritarian, even fascistic ideals, and a sense of egalitarianism.

Jacob Epstein
1880–1959

Torso in Metal from
The Rock Drill
1913–14
Bronze
70.5 × 58.4 × 44.5 cm

Jacob Epstein, *Study for 'The Rock Drill'* c. 1913
charcoal on paper 64.1 × 53.3 cm

Jacob Epstein was born in New York to Polish-Jewish parents, but settled permanently in England in 1905. He was one of the most successful but also controversial sculptors at work in Britain in the first half of the twentieth century. Like Bomberg and other avant-garde artists, at the beginning of the 1910s Epstein was concerned with specifically modernistic themes of mechanisation and violence. *The Rock Drill* was first conceived as a complete figure mounted on a real drill, presenting a celebratory view of the fusion of man and machinery. Epstein prepared a plaster version of the sculpture, and there is a drawing by the artist showing his original idea. However, the reality of the First World War forced Epstein to check his illusions about the positive effects of modernity. In the event, he cast only the torso in bronze, pointedly leaving the right arm incomplete. Thus a work that started as a celebration of the dynamism of the modern world ended as a mutilated emblem of the carnage of war. The foetus-like form in the belly of the figure was said by Epstein to represent the 'progeny of the future', a symbol of hope perhaps, but one brutally encased and constricted within an exaggeratedly masculine figure.

Gwen John
1876–1939

Nude Girl
1909–10
Oil on canvas
44.5 × 27.9 cm

The female nude has been a stock subject for artists throughout the centuries, but John's treatment of the model is exceptional for this date in its naturalism and its suggestion of psychological intensity. The model was Fenella Lovell, whom John disliked deeply. In 1909 she wrote of Lovell, 'It is a pretty little face, but she is *dreadful*'. While paintings of nudes traditionally stressed the sensual qualities of flesh, and tended to present the model as unselfconscious in order to create a sense of her complicity with the viewer's enjoyment of her body, John's nude is depicted in a state of confrontational self-awareness. John was one of the most original artists of her generation, but her reputation was overshadowed by that of her brother, Augustus John. However, her intensive investigations of female identity – her sitters were almost exclusively women – has chimed with contemporary feminism. John's cruel comment about her model and the harshness of this image may suggest the complexities involved when a woman takes up a subject traditionally treated with a specifically male viewpoint in mind.

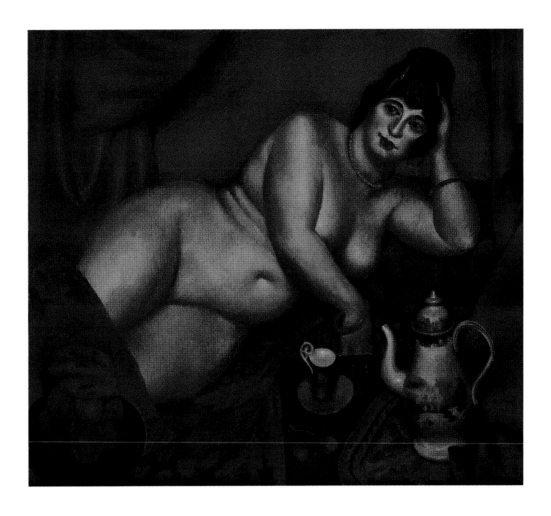

Mark Gertler
1891–1939

Queen of Sheba
1922
Oil on canvas
94 × 107.3 cm

Mark Gertler was one of the few avant-garde artists of early British modernism not to come from a conventional middle-class background. A Russian-Jewish immigrant who grew up in London's East End, Gertler was identified as an 'outsider' and his art was particularly appreciated for its supposed earthiness and honesty. After his daring, modernist works of the 1910s, during the 1920s he produced a series of more monumental female nudes, of which this is an example.

Though the exaggerated colours and simplified volumes show Gertler's artistic modernism, the picture has the solidity of more traditional art. After the innovations of the previous two decades, and more pointedly, following the trauma of the First World War, many critics and patrons were eager to see art express a sense of stability and permanence, exemplified in the 'timeless' beauties embodied in the female nude.

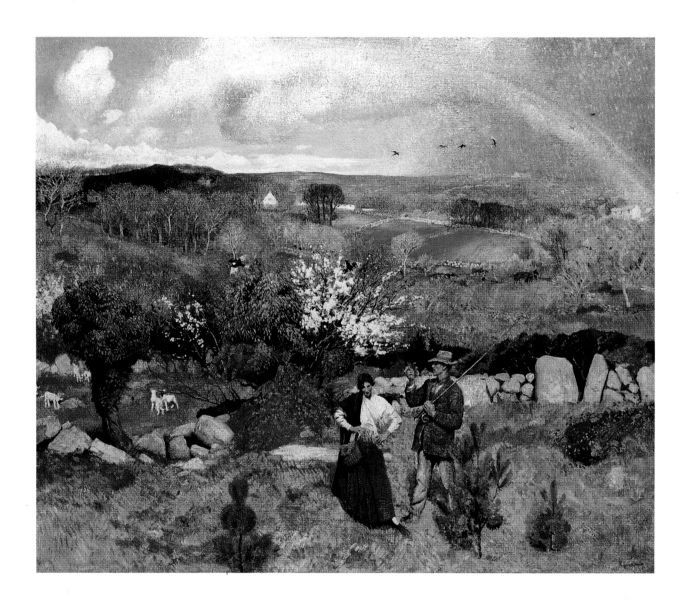

Laura Knight
1877–1970

Spring
1916–20
Oil on canvas
152.4 × 182.9 cm

Knight was best known for her pictures of the circus and the theatre, and used a painting style based on the models of French Impressionism and Post-Impressionism. This picture was painted when Knight was living in Cornwall, an area that attracted many artists in the early decades of the twentieth century. It shows the Lamorna Valley near Newlyn. The two figures are Knight's neighbours, Ella and Charles Naper. Knight was one of the most successful painters of her generation, and only the second woman to be elected a member of the Royal Academy. As a woman working in the male-dominated art world, and as someone from an impoverished background rather than the privilege enjoyed by many of the avant-garde artists of the time, Knight's assumption of a relatively traditional painting style allowed her to acquire success on the terms offered by the conservative art establishment. Her somewhat unconventional lifestyle (she associated with travellers and circus performers) brought her publicity, but also registered a sense of personal alienation from the mainstream art world.

Graham Sutherland

1903–1980

Welsh Landscape with Roads

1936

Oil on canvas

61 × 91.4 cm

This is one of a series of images of Pembrokeshire in Wales produced by Sutherland in the late 1930s. This was an area of Britain appreciated for its natural beauty and particularly its romantic associations with the mythical Celtic past. While other artists of the period sought in the native landscape a sense of timelessness and reassuring calm, Sutherland's work is distinct for its dramatic and unsettling treatment of the genre, here marked by the introduction of the mysterious running figure and the animal's skull in the foreground. Although his use of enveloping, semi-abstract arabesques and disruptive symbolic elements was clearly indebted to the modernism of Picasso and the Surrealists, Sutherland's preoccupation with the landscape meant that he was positioned as a distinctly English sort of artist, rooted in the mystical tradition of William Blake and Samuel Palmer. However, it was only after the Second World War that Sutherland was able to commit himself to painting; during this period, he was still teaching printmaking and working as a designer to make ends meet.

Stanley Spencer
1891–1959

**The Resurrection,
Cookham**
1924–7
Oil on canvas
274.3 x 548.6 cm

This is the largest and most elaborate of a series of images produced by Spencer depicting his home village of Cookham on the Thames in Berkshire, transformed into visionary scenes. In this case he shows the Christian Resurrection taking place in the local churchyard. Jesus sits in a throne in the church doorway, with God leaning over the back of the throne, and ancient prophets are ranged against the side of the church. Throughout the rest of the picture, figures are rising from their graves, including a segregated group of black people. The picture includes a number of autobiographical elements whose significance remains unclear: the artist himself appears, naked, standing between two gravestones, and his new wife, Hilda Carline, appears at least three times, most notably in the fenced-off ivy bush in the foreground. Spencer's brother-in-law, Richard Carline, is the naked male figure to the right of the ivy. When it was exhibited at a commercial gallery in 1927, the picture received almost universal acclaim. The artist's combination of parochial subject matter, startling technique and formal distortions suggested both a personal adaptation of modernism and an attachment to the most wholesome myths of traditional English life, spiced up with themes of sexual experimentation and frustration.

Stanley Spencer
1891–1959

**St Francis and
the Birds**
1935
Oil on canvas
66 × 58.4 cm

This is a fragment of a design for a decorative scheme for a chapel that Spencer planned to paint following his famous work at the Sandham Memorial Chapel at Burghclere in the 1920s. The later scheme was never realised, but it is known that Spencer planned to centre it around scenes based in his village of Cookham in Berkshire, where the artist spent most of his life. Typically, Spencer based his visionary religious painting on his experience of the everyday. The costume of St Francis refers to Spencer's memories of his father in his dressing gown and the setting is the passageway between the Spencer family home in Cookham and the neighbouring cottage. The painting developed from a drawing made by Spencer of his first wife, Hilda Carline, sitting in a haystack surrounded by chickens and ducks. This work epitomises the personal and celebratory vision of nature that is found in Spencer's work. Both the naturalism and eccentricity of the image typify the clichés about Englishness that became dominant during the twentieth century.

Edward Burra
1905–1976

Soldiers at Rye
1941
Gouache,
watercolour and ink
wash on paper
102.2 × 207 cm

During the 1930s Burra specialised in macabre images of the low-life of Europe's ports, and was associated with the Surrealists. After a series of travels on the Continent and America, he returned to his hometown, Rye in Sussex. The starting point for this image was the sight of soldiers at their camp near Rye. However, Burra transformed them into fantastical, bird-like figures, perhaps to underscore the ludicrousness of war. In rendering modern soldiers as medieval combatants in comic costumes the artist may be referring to the outmoded, courtly ideal of combat which he would have known about from his reading of sixteenth- and seventeenth-century poetry. Burra came from a stable middle-class background and after his youthful travels settled down to life in his family home, where he was able to indulge his personal vision largely without worrying whether his work would sell. Indeed, during his lifetime he was generally dismissed as a caricaturist, rather than being considered as a 'serious' artist.

Henry Moore
1898–1986

**Four-Piece
Composition:
Reclining Figure**
1934
Cumberland alabaster
17.5 × 45.7 × 20.3 cm

Henry Moore emerged in the 1930s as the leading sculptor of British modernism. His work combined abstraction, free-ranging symbolism and a clear sense of connection with nature, particularly the native landscape of Britain. This work suggests the forms of a reclining figure, with the arched form as a bent leg, the large upright form as a head, and the small round form a navel. By untying the forms of the body,

Moore sets in motion a whole chain of possible associations, and together these shapes suggest simultaneously a figure, a landscape, or pebbles and bones. Moore's work became famous in a period of anxiety and nostalgia in Britain. His use of a fine, indigenous material, the references to the landscape and the stillness and classical quality of his work played to these feelings, while retaining the look of avant-garde modernity.

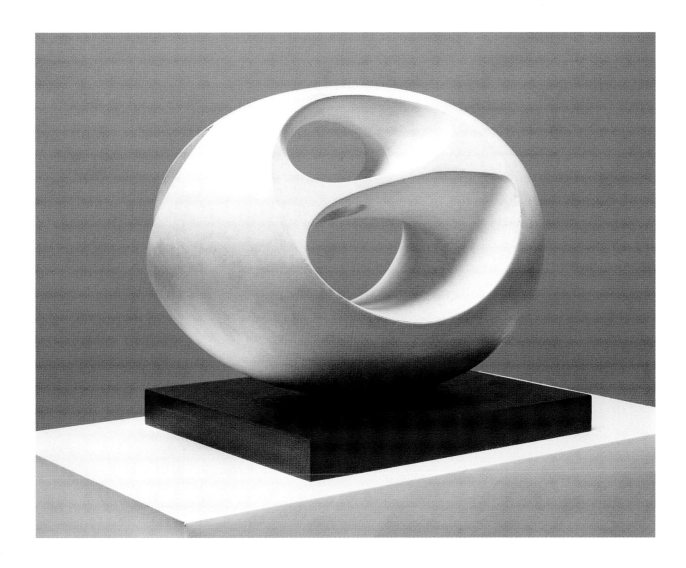

Barbara Hepworth
1903–1975

Oval Sculpture
(No.2)
1943, cast 1958
Plaster
29.3 × 40 × 25.5 cm

This is a plaster cast of a work originally carved in wood. Hepworth was, with Ben Nicholson, Henry Moore and others, one of the artists associated with the avant-garde Seven and Five Society. They were among the first British artists to express a wholehearted commitment to abstraction, and their work owed much to the example of European modernism. Unlike some of their Continental counterparts, the artists of the Seven and Five Society all acknowledged some debt to the observation of nature, and this work makes reference to organic forms. The oval allowed for a complex arrangement of a shape with two centres, and the hollows draw attention to the internal spaces of the work. As an abstraction, the work establishes a range of associations, with eggs, the womb, shells and the landscape of the Cornish coast, where Hepworth was based. A number of artists were exploring the same forms at this time, and the Russian artist Naum Gabo, who was working in England, accused Hepworth of 'stealing' the oval from him.

Ivon Hitchens
1893–1979

Damp Autumn
1941
Oil on canvas
40.6 x 74.3 cm

During the 1930s Ivon Hitchens was closely associated with the avant-garde artists who lived in Hampstead in north London, including Hepworth and Moore. He painted figure studies, murals and still lifes, but it is for his landscapes that he is best remembered. *Damp Autumn* was produced when Hitchens and his young family moved to Lavington Common near Petworth in Sussex. Although bordering on abstraction, the colours of this painting are directly evocative of the English landscape, while the formal structure of the image refers back to the traditions of landscape painting – the long format of his canvases recalling the shape of Turner's paintings of Petworth. Like other artists of the period, Hitchens's work can be associated with the growing sense of nostalgia for the countryside, and the profound sense of national identity it embodied, during a period of economic crisis and war.

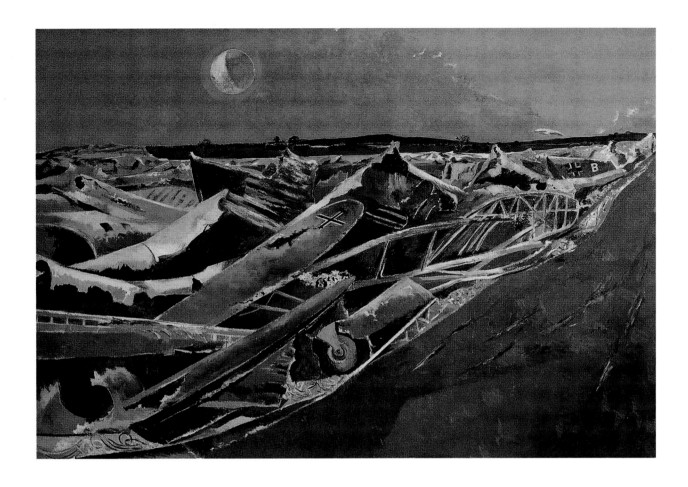

Paul Nash
1889–1946

**Totes Meer
(Dead Sea)**
1940–1
Oil on canvas
101.6 × 152.4 cm

Nash was one of the most influential artists of his generation, and his use of landscape imagery as a vehicle for disturbing Surrealist fantasies was to have considerable impact. During the war, he was appointed as an official war artist, attached to the Air Ministry. This painting is based on a set of photographs taken by Nash of a dump for wrecked German aircraft at Cowley, near Oxford. The scene suggested a turbulent sea, an effect Nash has heightened in his painted depiction. The combination of bizarrely metallic waveforms and brooding colour establishes an unsettling tone and reveals a sense of tension between the natural world and industrial, modern life that was widespread at mid-century. As it had for other artists of his generation, the war provided Nash with the occasion to draw on the artistic innovations of the previous decades in an art intended for a much broader public and produced with a real sense of social purpose.

Photograph by Paul Nash of wrecked aircraft, Cowley Dump 1940

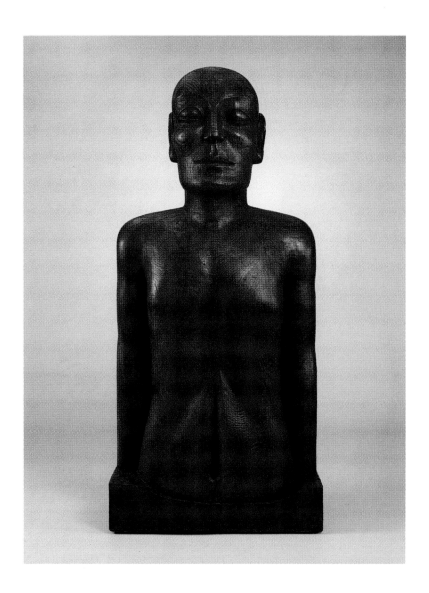

Ronald Moody
1900–1984

Johanaan
1936
Elm
155 × 72.5 × 38.8 cm

The Jamaican-born sculptor Ronald Moody settled in London in 1923 to study dentistry. In the late 1920s he started to experiment with sculpture, having been inspired by the Egyptian sculptures he had seen at the British Museum and his own esoteric philosophical interests. This work was among his earliest finished pieces, and was exhibited as part of his solo exhibitions in Paris and Amsterdam in 1937 and 1938 respectively. The shows were a great critical success, and one French critic lauded the way Moody seemed to 'plumb the depths of a time-honoured tradition which never ceases to exert its magic over us'. Moody's sculpture was admired for its primal and timeless qualities, at a time when these 'primitive' qualities had widespread appeal among intellectual circles facing an increasingly turbulent political scene. However, following the initial acclaim of his work in the late 1930s, Moody had to continue his work as a dentist on a part-time basis in order to finance his art and was largely ignored by the British art establishment. More recently there has been a revival of interest in his work, and his distinctive reinterpretation of the 'primitive' has been compared favourably with the more familiar, mainstream work of his contemporary Henry Moore.

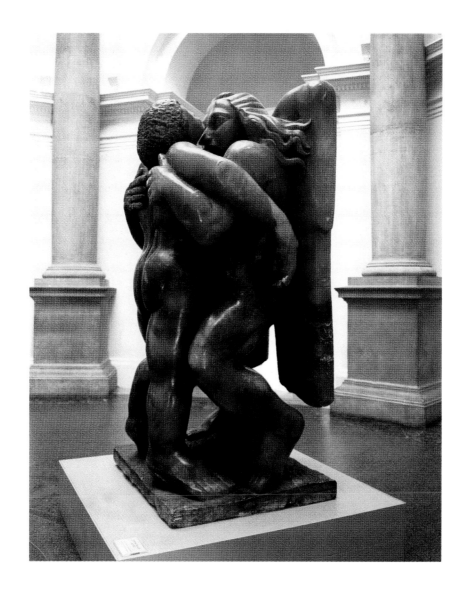

Jacob Epstein

1880–1959

Jacob and the Angel

1940–1

Alabaster

243.8 × 121.9 ×
121.9 cm

Epstein's work combined a concern with the materials and processes of sculpture typical of modernism, with religious and allegorical subject matter. The subject of *Jacob and the Angel* is taken from the Book of Genesis (32:24–32) which describes how Jacob was forced to wrestle with an unidentified opponent throughout the night. In the morning, the opponent revealed himself to be an angel, who blessed Jacob for not giving up the struggle. Epstein expresses the story's theme of spiritual fortitude in the gigantic proportions of his figures, drawn from the example of so-called 'primitive' sculpture. The implicitly sexual nature of their embrace is typical of Epstein's work; his public monuments were often criticised for their eroticism, though the artist's bold use of 'primitive' forms, with their associations with 'undeveloped' African cultures, also caused offence. The controversy was aggravated by the fact that Epstein was foreign-born and Jewish, thus drawing out the prejudices of mainstream British culture.

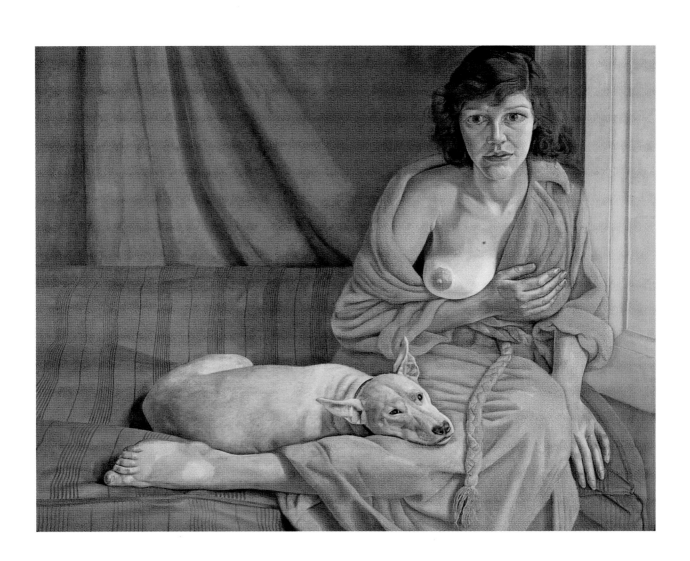

Lucian Freud

born 1922

**Girl with
a White Dog**
1950–1
Oil on canvas
76.2 × 101.6 cm

At the end of the 1940s, Freud painted a series
of portraits of his first wife, Kitty Garman, of
which this is the last. During this period, the
artist was working in an extraordinarily detailed
painting style that resonated with a sense of
tradition. The precise draughtsmanship and
highly finished surface of this painting refers
to the work of the nineteenth-century French
painter Jean-Dominique Ingres, the epitome of
traditional, academic art. Yet the almost chilling
observational powers of the artist, the curious
rhyming between the forms of the woman and
dog, and the intensity of the sitter's expression,
suggest a psychological ambiguity and depth
that complicates the apparent sensuality of
the picture. The slight distortions of the sitter's
features, emphasising the eyes and mouth,
are typical for Freud during this period, and
heighten the look of painful loneliness in
her face. Freud's combination of painstaking
technique with a psychological intensity that
chimed with the pessimism of contemporary
intellectual life won him many admirers.

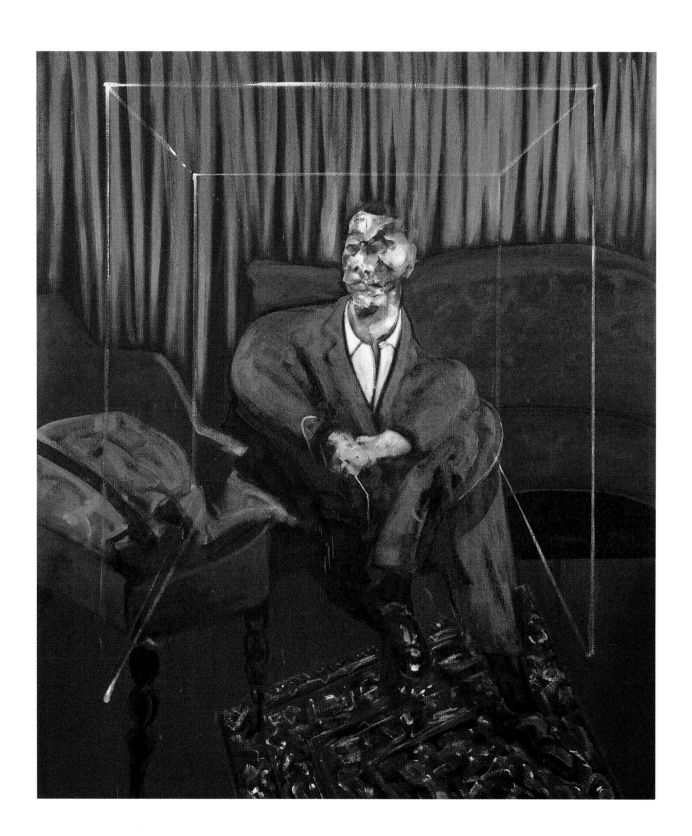

Francis Bacon
1909–1992

Seated Figure
1961
Oil on canvas
165.1 × 142.2 cm

Bacon is widely considered to be the greatest post-war British painter. His best-known works show violently contorted human figures in blandly conceived interiors. The visceral quality of the paint, and the characteristic distortion of the figure and his features, suggest some sort of violence or distress, even when, as here, the figure is at rest. Bacon's ability to convey a sense of fleshy reality through his evocative use of oil paint and his exploitation of chance effects was especially admired. The immediacy of his style and apparently nihilistic subject matter suggested an 'existential' outlook favoured among many intellectuals in the post-war period. Existentialists argued that man is defined only by his free actions in a universe without moral order, a creed both pessimistic and, it seemed, strangely glamorous. Bacon was seen as expressing the negativity of post-war culture with great power, but his gestural painting style and chaotic life-style also signalled his vital 'authenticity' as an artist at a time that a sense of emotional honesty and realism were particularly valued.

Peter Lanyon
1918–1964

Lost Mine
1959
Oil on canvas
183.2 × 152.7 cm

Peter Lanyon, *Construction for 'Lost Mine'* 1959,
glass, paint and Bostick 53.8 × 48.3 × 27 cm

Peter Lanyon was born in Cornwall, and studied at the Penzance School of Art. He came into contact with the modernist artists Ben Nicholson, Barbara Hepworth and Naum Gabo when they came to St Ives in 1939. He started producing constructions after their example, but in the 1950s developed a more personal and gestural style of painting analogous with the American Abstract Expressionists. Like the Americans, Lanyon frequently painted on a large scale using bold colour and broad and expressive gestures. However, his work generally refers to the landscapes of England, and conveys a sense of constructed space rather than simple painterly flatness. In preparing his paintings, the artist would often work through his ideas using three-dimensional construction. The title of this painting refers to an actual event – the flooding of a Cornish tin mine. Lanyon's understanding of the landscape was transformed in 1959 when he took up gliding, and this painting suggests the landscape and sky seen from the air.

Anthony Caro
born 1924

Early One Morning
1962
Painted steel
and aluminium
289.6 × 619.8 ×
335.3 cm

Anthony Caro worked as Henry Moore's assistant but, influenced by new American art and art theory, made a decisive break from his example at the end of the 1950s. Where Moore was concerned above all with the idea of the image emerging from the sculptor's materials, whether clay, stone or wood, Caro developed an alternative approach centred around constructive methods using modern metals and a novel sense of lightness and space, based on the model of the American sculptor David Smith. Caro's use of open forms, his avoidance of any explicit figurative reference, and his insistence his sculpture be placed directly on the floor rather than on a pedestal, indicate his desire that sculpture be a 'direct' experience. The painting of the entire piece in one colour allows it to be read as a whole, and means that the patination found in more traditional kinds of sculpture is avoided. The change in Caro's work, which won him many supporters, marked a move away from the pessimism of the immediate post-war period and presented a response to the increasingly dominant American avant-garde.

Richard Hamilton

born 1922

$he

1958–61
Oil, cellulose
paint and collage
on wood
121.9 × 81.3 cm

This work offers a reflection on American consumer culture, particularly its use of female sexuality to sell goods. The source of the image was a photographic advertisement for a fridge-freezer; the open door of the freezer is visible on the right. The woman is represented by the toy winking eye, a portion of her shoulder, and a simplified and almost abstract form in low relief representing her hips. At the bottom of the picture is an image showing a combination of a vacuum cleaner and a toaster. These electrical wares were new features in middle-class British households in the 1950s, viewed as exciting icons of American-style modernity by many people and heavily promoted through the new media of glossy magazines and television. Hamilton's painting, with its disturbing fragmentation and nods towards the grotesque, conveys an ironic perspective on consumer culture. The woman in this image is presented as an object, in the same way as the toaster is. Hamilton was personally acquainted with the graphic techniques of commercial advertising and engineering, and this composition refers to both of these in its fragmentation and strange viewpoint.

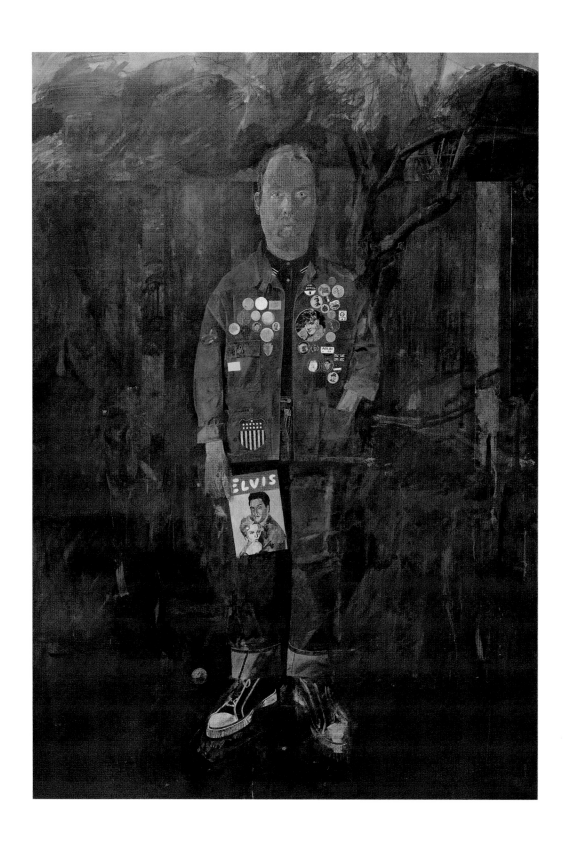

Peter Blake

born 1932

Self-Portrait with Badges
1961
Oil on board
174.3 × 121.9 cm

Peter Blake was one of the leading exponents of English pop art. His work of the early 1960s dealt with the influence American culture exerted over the younger generation in Britain. Blake depicts himself wearing a denim jacket (itself a sign of American pop culture) encrusted with badges referring to mainly American icons, including Elvis Presley and Pepsi Cola. He also holds a magazine with Elvis on the cover and wears American-style high-top 'sneakers' on his feet. All this Americana is undercut – or perhaps underscored – by the setting suggested in the background, a typically English suburban back garden. Few of the English pop artists actually travelled to America, and their knowledge of American culture was based largely on magazines, films and pop music. Blake owned the badges himself, some of which he had kept since childhood. His impassive presentation of himself as a slightly portly thirty-year-old man dressed as an American teenager offers a wryly ambiguous comment on the appeal of pop culture, where it is unclear whether the artist is complicit with the fantasy promoted through magazines and pop culture, or not.

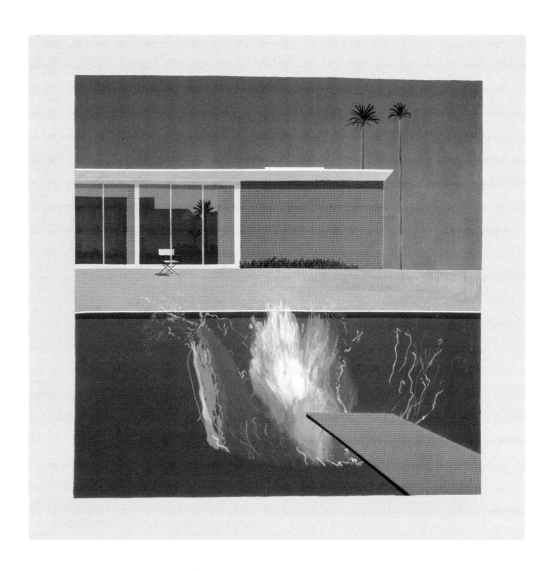

David Hockney
born 1937

A Bigger Splash
1967
Acrylic on canvas
242.6 × 243.8 cm

The Bradford-born artist David Hockney moved to Los Angeles in 1964, and his work changed radically with this relocation. Whilst in England he was a painterly artist, whose work contained complex allusions to other art, literature, pop and gay sub-culture, once in Los Angeles his work took on a detached, cool look that give a persuasive sense of the perceived superficiality of life in that city. In 1966–7 Hockney painted a series of views of swimming pools, based on a photograph in a technical book on swimming pool construction. *A Bigger Splash* is the most simplified of these, and its bold colour and flatness of design were made possible through the use of acrylic paints, then a relatively new artist's medium. The architectonic structuring of the image is suggestive of the cleanly designed spaces of California, while the blandness of the picture's surface embodies the newness and lightness that were a revelation to the Englishman. The stillness of the image is a deliberate conceit, given the split-second nature of the splash itself. In an oblique way, the image refers to the sense of novelty and liberation Hockney felt in America.

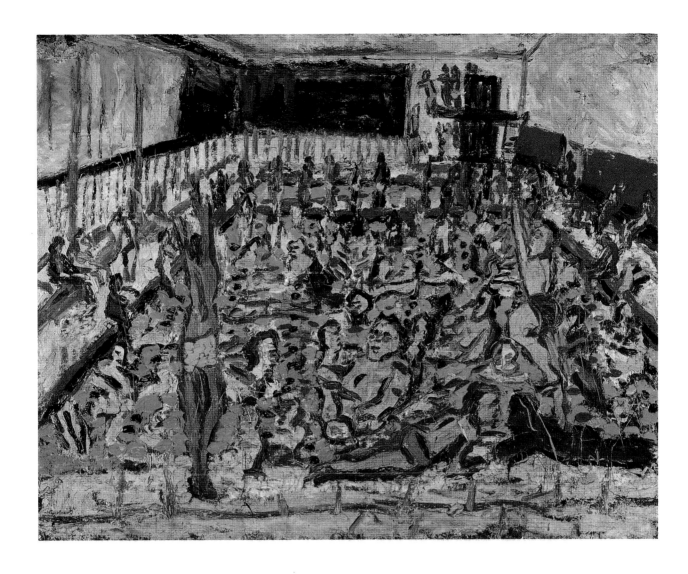

Leon Kossoff
born 1926

**Children's
Swimming Pool,
Autumn Afternoon**
1971
Oil on board
168 × 214 cm

Between 1969 and 1972 Kossoff produced four large paintings of this swimming pool, which was near his home in Willesden in north-west London. He made many studies of the pool, and became fascinated by the changes in the atmosphere across the seasons, and the different effects of sound there. This interest in visual facts and the painterly quality of this work are representative of the approach of the so-called School of London. The artist grew up in London, and the city is of special importance to him. He has written, 'The strange, ever changing light, the endless streets and the shuddering feel of the sprawling city lingers in my mind like a faintly glimmering memory of a long forgotten, perhaps never experienced childhood, which, if rediscovered and illuminated, would ameliorate the pain of the present'. With the continuing dominance of American Abstract Expressionism, the works of Kossoff and others of the School of London represented an alternative tradition developing out of modernism in its concern to test the technical and expressive potential of paint, but more closely tied to the experience of the real environment.

Photograph by David Hockney of Ossie Clark and Celia Birtwell

David Hockney
born 1937

**Mr and Mrs
Clark and Percy**
1970–1
Acrylic on canvas
213.4 x 304.8 cm

This portrait shows husband and wife Ossie Clark and Celia Birtwell. They were the most fashionable designers of the period, and played a key role in establishing London at the heart of the 'Swinging Sixties'. Hockey met Ossie Clark when they were living in Notting Hill in west London. Both working-class northerners riding on the wave of the 1960s cultural revolution, they became close friends. This carefully balanced portrait was the result of a long period of preparation, using drawn studies, and photographs. The studied stillness of their postures, the tension between their forms, and strange details (the bare feet of Ossie Clark, the isolated telephone and lamp) combine to suggest psychological tensions and depths. The unconventional character of their marriage (Ossie was primarily homosexual) may be signalled by the fact that the wife is standing and dominant in the picture. (Conventionally the female sitter would be shown seated.) The cat on Ossie's lap was actually called Blanche. Percy was the name of the couple's other cat, and is also a slang term for penis, perhaps adding a sexual aspect to the relatively submissive figure of the man.

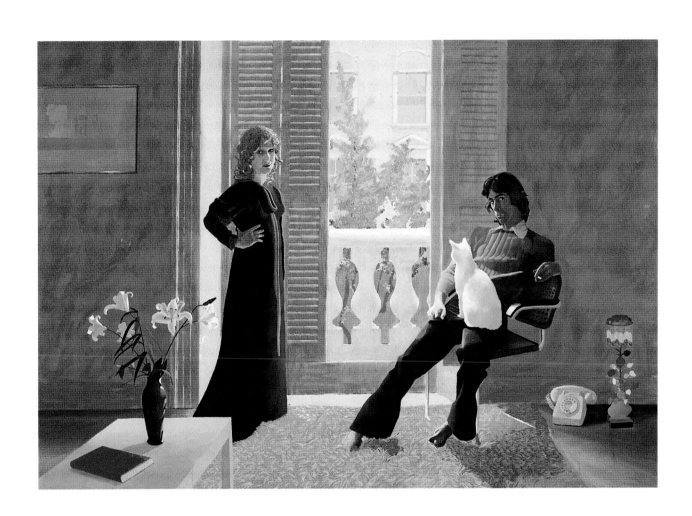

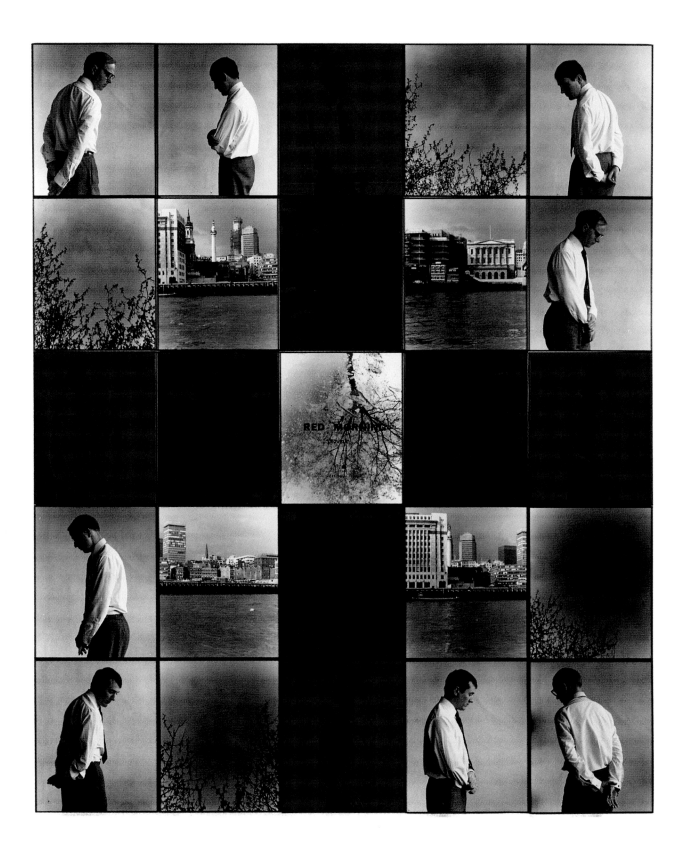

**Gilbert
and George**
born 1943,
born 1942

**Red Morning
Trouble**
1977
Photographs
on paper
302.5 × 252.5 cm

Gilbert Proesch and George Passmore (now always known as Gilbert and George) met while students at St Martin's School of Art in the late 1960s, when a whole generation of younger British artists were using the radical potential of filmmaking, performance and alternative media to challenge the dominance of traditional art forms. In 1970 they proclaimed themselves 'living sculptures' and have consistently used their distinctive, besuited figures as the raw material for their art since that time. They have worked with video, performance and drawings (all designated 'sculptures'), but since 1980 the dominant form has been monumental photo-montages, which often feature confrontational images of religion, urban decay and the naked male form. *Red Morning Trouble* portrays the artists in contemplative attitudes alongside panels showing commercial buildings lining the Thames. The title and their postures suggest the oppressive character of modern business life in the capital. The heroic scale and directness of their work, and the apparent seriousness of their themes, link them to a tradition of pictorial storytelling, an association reinforced by the characteristic grid of black lines created by the individual frames of their photos, which recall medieval stained glass.

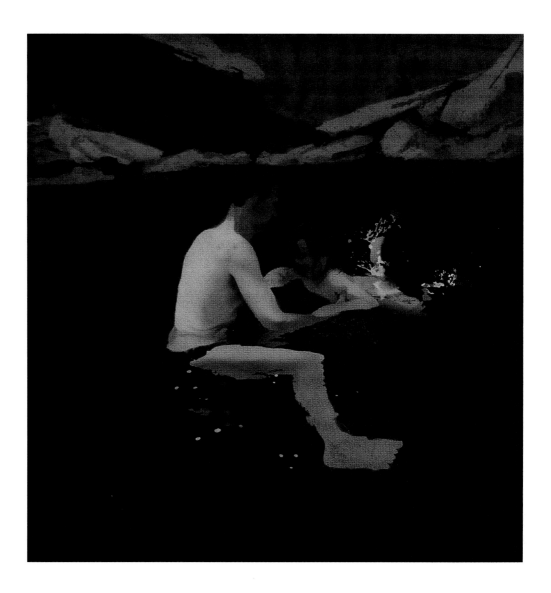

Michael Andrews
1928–1995

Melanie and Me Swimming
1978–9
Acrylic on canvas
182.9 × 182.9 cm

Michael Andrews was one of the leading British figurative painters to emerge in the post-war period. Like Bacon, Freud and Kossoff, Andrews's work shows an experimental approach to the process of figurative representation. His images developed slowly from a combination of observation, imagination, memory, and a prolonged engagement with the practical problems of painting. *Melanie and Me Swimming* is a self-portrait with the artist's daughter. The final image was based on preparatory watercolours, which were in turn based on a photograph. The painting was executed using brushes, but also a spray gun and, for the rocky surfaces at the top of the canvas, strips of cloth soaked in colour. The stark contrast between the figures' white and pink bodies and the unfathomable darkness of the water, and the suggestion of the transitory character of their touch, gives a strong sense of temporality. Andrews's images, which were often worked on for long periods, can be seen as meditations on human existence. Beyond being a simple observation of family life, the picture is suggestive of the tender but fragile relationship between a father and a daughter who is on the point of detaching herself to enter society at large.

Howard Hodgkin
born 1932

Clean Sheets
1979–84
Oil on wood
55.9 x 91.4 cm

Hodgkin's work, though apparently almost wholly abstract, derives from his personal experiences and memories. His paintings refer to private feelings, meetings, or conversations, which he strives to embody through a rich vocabulary of abstract painterly marks. In that sense, his work continues in the tradition of the early twentieth-century French artists Vuillard, Bonnard and Matisse, and the Bloomsbury artists who imitated them. The decorative qualities of his paintings, and in some cases specific ornamental elements, derive in a very broad sense from traditional Indian painting, which Hodgkin has collected since he was a child. The title, deep colours and the flash of pink paint to the bottom left which may suggest a human presence, hint at a sexual encounter, a common theme in Hodgkin's works. The artist's extra-ordinary technique and the exuberant but precious quality of his works, which often take years to complete, have ensured an international reputation for him among critics and collectors.

Richard Deacon

born 1949

If The Shoe Fits

1981

Steel

160 × 325 × 184 cm

Deacon's allusive titles and use of varied, often 'non art' materials show an interest in text and meaning that was a feature of the conceptual art of the 1960s and 1970s. As a student at St Martin's School of Art during 1969–72, where he became intensely interested in the study of language, Deacon's work was first based around performance. Subsequently he became more concerned with producing physical objects. This is the first of his works to receive a title rather than being left as 'untitled', and thus marks a shift away from the strict formalism and factuality of high modernism towards a more poetically suggestive kind of sculpture. The shapes of his sculptures often recall body parts or domestic objects, and his use of materials opens up questions about the boundaries between sculpture and other objects in the world, a theme found in the early modernism of Marcel Duchamp and Constantin Brancusi. The title of this work comes from a commonplace saying ('if the shoes fits, wear it') further emphasising Deacon's desire to refer to the world outside of high culture.

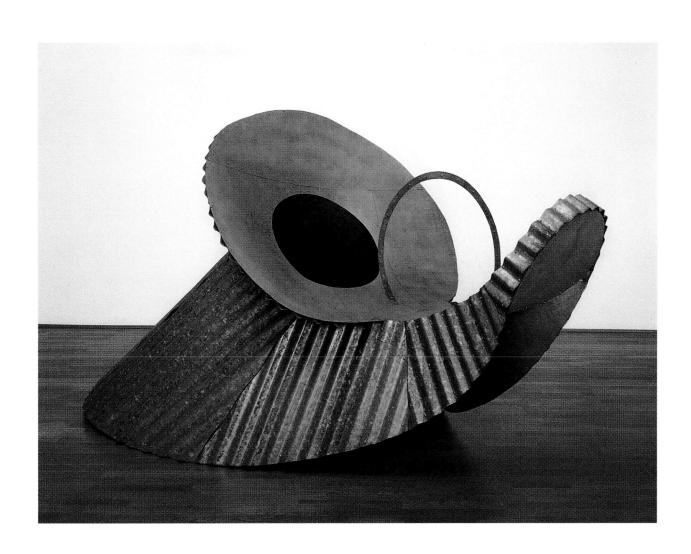

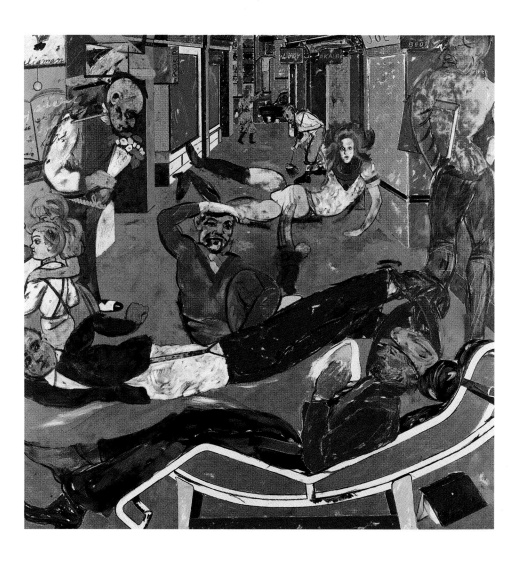

R.B. Kitaj
born 1932

**Cecil Court,
London W.C.2.
(The Refugees)**
1983–4
Oil on canvas
183 × 183 cm

Kitaj is an American who settled in London at
the end of the 1950s. He is particularly admired
for his draughtsmanship and the complexity
of his images, which draw on a wide range of
sources including Surrealism, literature, pop
culture, and, especially since the 1970s, Jewish
tradition. Kitaj identifies closely with the
experience of the Diaspora (the dispersal of
the Jewish peoples over history) and the impact
of the Holocaust. This painting explores these
themes. It represents a scene in Cecil Court, near
Trafalgar Square, a small alleyway filled with
specialist booksellers, many of whom are Jewish
refugees. The artist associates the bizarrely

distorted and shabby figures with the shadowy
world of the Yiddish Theatre, which he knew
about through his grandparents. The picture
contains a number of highly personal references
and portraits, including one of the artist himself,
reclining in a chair wearing the jacket and tie he
was recently married in. The figure on the left
holding flowers is Ernest Seligmann, a Jewish
refugee who ran a specialist art bookshop in
Cecil Court frequented by Kitaj. As a critic and
writer, Kitaj has celebrated the eccentricity and
individualism of post-war British figurative art –
qualities found in his own work.

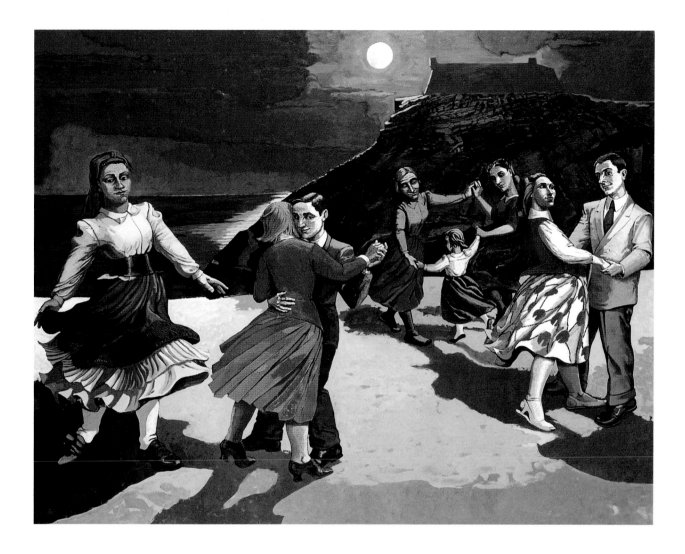

Paula Rego

born 1935

The Dance

1988

Acrylic on paper laid
on canvas

212.6 × 274 cm

Since the late 1980s, Rego has produced a series of monumental images based around memories of her childhood in Portugal. The chunky proportions of her figures and lucid pictorial technique suggest an illustrational approach, but her works feature disturbing discontinuities of scale and psycho-sexual elements that undermine any apparent fairy-tale innocence. This large painting can be read as a 'dance of life', involving a series of female figures of different ages, from childhood to old age and including a pregnant woman on the right. The two men in the scene may represent Rego's husband, the painter Victor Willing, who died while the artist was making this work. The castle in the background was known to Rego as a child, and later in life she moved nearby with Willing. Rego's work, with its themes of childhood memory and sexuality, has been seen as embodying a specifically female (and feminist) outlook on life.

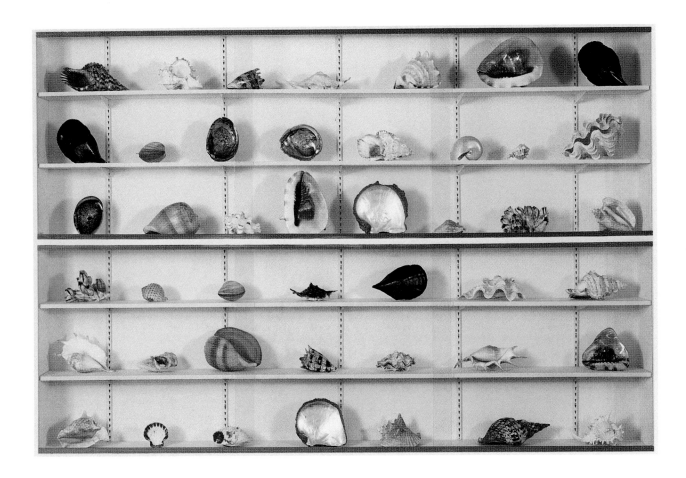

Damien Hirst

born 1965

Forms Without Life

1991
MDF cabinet,
melamine, wood,
steel, glass and
sea shells
183 × 274.6 ×
30.7 cm

As an artist and as a curator, Hirst has been one of the most influential figures of his generation, and is particularly identified with the resurgence of international interest in contemporary British art in the early 1990s, notably the emergence of the so-called Young British Artists. Hirst's own work takes a variety of forms, from large-scale installations through to minimalist abstract painting. His most notorious works involve the use of animal carcasses. Here, seashells are ranged along the shelves of a glass-fronted cabinet. The grid-like structure of the cabinet refers to the most severely formalist kinds of modernist sculpture, where simple forms would be repeated and transparent materials deployed to create a sense of openness and structural honesty. But in using this form as the container for shells (rather than as 'pure' form), Hirst makes witty reference to ideas about collecting and preservation, suggesting at once the conventions of museum display, the medicine cases found in chemist shops, and the sterile conditions of the science laboratory. The work also makes reference to the whole tradition of still-life painting, where inanimate objects are used to make symbolic reference to themes of life, death and the ephemeral nature of beauty.

The Great Bear

Simon Patterson

born 1967

The Great Bear

1992

Lithograph on paper

102.7 x 128 cm

One of the best-known individual works by a contemporary British artist, Patterson's *Great Bear* shows the artist's preoccupation with the presentation of information in its various forms. His works combine text and image, diagrams, maps and tables, appearing in wall drawings, paintings and installations. In this print the artist has reproduced the London Underground map, a design acknowledged as a masterpiece of rational modernism. However, the names of the tube stations have been replaced by the names of philosophers, film stars, kings, comedians and other celebrities from history and the present day. In the context of the map, a model of graphic lucidity, these alterations wittily point to the arbitrary nature of our values about authority and knowledge. Patterson intended to use the image as a poster in the Underground, but there were worries that it would confuse passengers.

Gillian Wearing

born 1963

10-16
1997
Video

Gillian Wearing's video work explores themes of self-revelation, deviancy and confession. This video is approximately fifteen minutes long, and features the voices of a series of children aged between ten and sixteen, dubbed over images of adult actors who lip-synch to their words. The interviews with the children become progressively more disturbing. In the first, a ten-year-old talks about his tree house. The last features a sixteen-year-old confessing his anxieties about his sexuality and admitting his painful self-consciousness. During the course of the video, any illusions about the innocence of childhood disintegrate. By dubbing children's voices over images of adults, Wearing adds another level of complexity. The children's voices act as confessionals of the 'inner child', here undermined by the disunion between voice and image. Like other contemporary British artists, Wearing exploits fully the candid potential of video, with a directness that recalls the conventions of documentary filmmaking.

Mat Collishaw

born 1966

Hollow Oak

1995

Video

The oak tree has long been a symbol of Englishness, and the oak has been variously associated with royalty, the ancient Druids, and rural marriage rituals. Landscape painters of the eighteenth and nineteenth centuries often included oaks in their pictures, using the tree as a way of identifying a distinctly English kind of scenery. In the twentieth century, oak trees have been represented in art for their romantic and nationalist connotations. Collishaw's *Hollow Oak* plays on these traditional associations, while drawing attention to the ways in which our perception of nature is mediated by culture. With *Hollow Oak* he literally frames the image of an oak tree with an historical object, an original wooden negative carrying case of a nineteenth-century camera. The image is projected onto etched glass, so that it takes on the appearance of early photography. However, this illusion is disrupted by the fact that the image is not still, and the viewer slowly becomes aware of the sound of the wind rustling through the leaves and the gentle bleating of the sheep.